EYES ON AN ERA

FOUR DECADES OF PHOTOJOURNALISM

IRVING HABERMAN

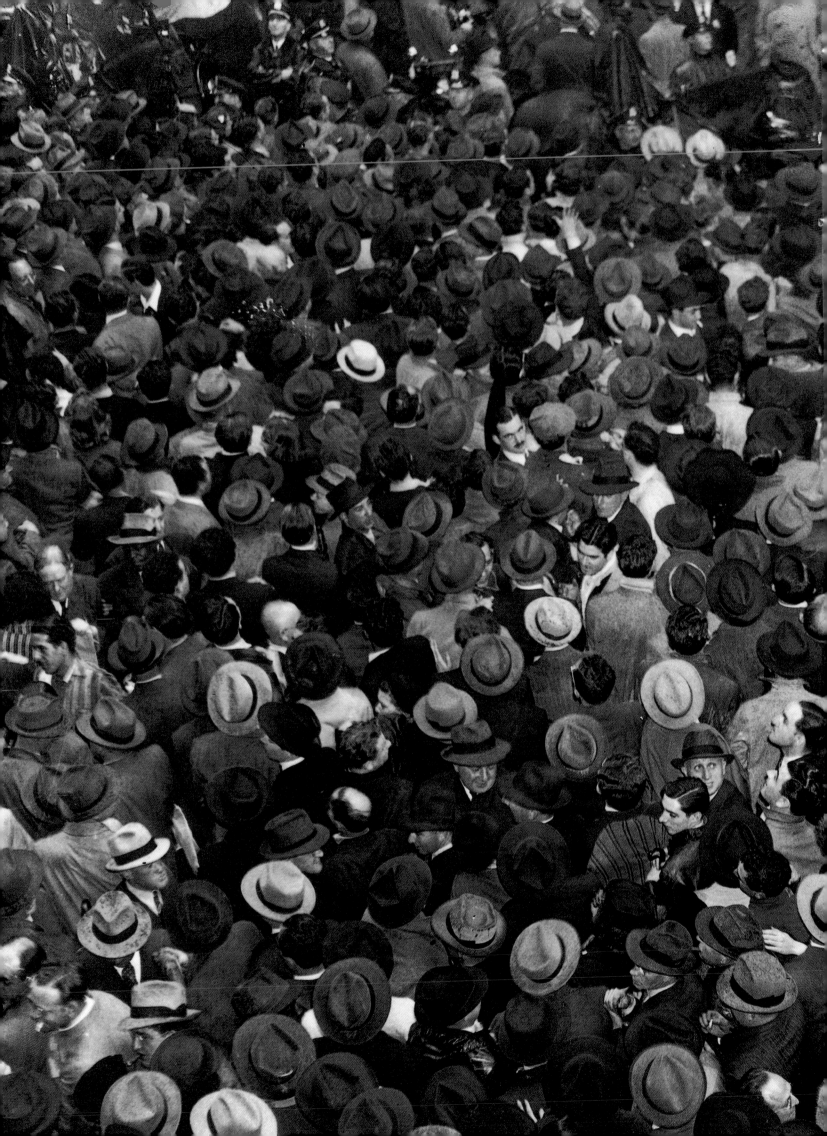

EYES ON AN ERA

FOUR DECADES OF PHOTOJOURNALISM

IRVING HABERMAN

COMMENTARY BY WALTER CRONKITE

EDITED AND WITH AN INTRODUCTION BY MILES BARTH

RIZZOLI
NEW YORK

contents

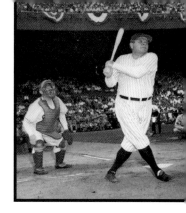

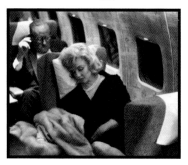

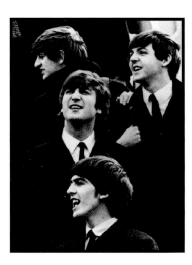

I dedicate this book to my beautiful wife of fifty-three years, Beulah, and to my wonderful children and grand-children—my "pussycats." I especially thank my grandson Michael Tarter, who made my dream and hope of a book of my photos come true.

Irving Haberman

On behalf of Three Trees Entertainment, owner of the rights to the Irving Haberman Photographic Collection, I am privileged and proud to present the photographs of Irving Haberman. *Eyes on an Era* is a treasure for both young and old to enjoy together— it is a photographic journey through one of the most memorable eras in our history, the events and personalities that have shaped our lives. I invite you to join us as we relive, through the eyes of Irving Haberman, those precious moments that we all share, the moments that bring us all a little closer.

Eric S. Medney
President, Three Trees Entertainment

ACKNOWLEDGMENTS It cannot go without saying that any project of this significance requires the assistance of a diverse and talented group of people. I am grateful to my friend Henry Buhl for introducing me to the work of Irving Haberman. For their encouragement and tireless efforts on behalf of the Haberman archive, I would like to thank Eric S. Medney, Steve Goldberg, and especially Ilyse Wilpon and Michael Tarter of Three Trees Entertainment. Jen Bilik's persistence and superb editing skills have made this publication a source of pride for all involved; others at Rizzoli have been a pleasure to work with, exhibiting extreme professionalism in every aspect of the project. Marty Silverstein, director of photo operations at CBS, provided invaluable research assistance. In Walter Cronkite's office, Marlene Adler and Julie Sukman helped at every step. I would like to extend thanks also to Marty Adler, John A. Olguin, Heidi Pokras, Mort Rubenstein, Walter "Izzy" Siegal, Sherman Winn, Diana Wiss, and the St. Louis Cardinals Hall of Fame Museum. The book's form is a result of Leslie Pirtle's creative mastery and unfailing commitment. Robert Solywoda spent many hours in the darkroom, producing extraordinary prints from negatives in conditions and formats that varied widely according to age. As a result, Haberman's work glistens on these pages.

Miles Barth

Irving Haberman. New York City, 1937. Photographer unknown.

This book is a dream come true for me—the pages that follow represent my life and everything I have worked to achieve. For over fifty years, I covered the news events and personalities of our time. Now in retirement and looking back, I remember my days of travel as among my happiest. I am grateful and privileged to have photographed some of the most influential people of our time—Ed Murrow, Walter Cronkite, Jackie Gleason, Elizabeth Taylor, John Glenn, Martin Luther King, Jr., Joe DiMaggio, Harry S. Truman, Eleanor Roosevelt . . . I shot 'em all.

I slept with (or at least next to) Marilyn Monroe; Ed Sullivan asked me to come on stage and sing for the audience during an intermission. I witnessed the first manned space flights from Cape Canaveral and Kennedy, traveled the country with Premier Nikita Khrushchev, and visited John F. Kennedy's home in Hyannis Port. I covered everything from the Brooklyn crime beat in the 1930s to the CBS reenactment of the Warren Commission's report with Dan Rather and Walter Cronkite. I was the only photographer allowed on the set during the first televised debate between Kennedy and Richard Nixon, and the only professional photographer at the wedding of Frank Sinatra and Ava Gardner. I covered the 1963 March on Washington, and the 1968 Vietnam War protests at Columbia University. And I will never forget New York sports legends such as Babe Ruth and Jackie Robinson who brought many a championship to a great city.

It has been almost ten years since I last worked professionally as a photographer. Now I enjoy spending time with my wife and family, whether at home in New York or Florida, sharing memories and sifting through old photographs. From a special room inside my house, I can recall almost any given time, both in this country's history and in my own, though the two seem to coexist in many ways. In this room, I preserve much of my old equipment—an old folding Kodak camera, a 4×5" Speed Graphic, a Rolleiflex (2¼" square), a Nikon F, and a Leica, along with flashbulbs, film packs, glass slides, and other antiquities.

On the walls of this room are framed prints of all the great people and times, yet the pictures of my family that fill the hallway leading to my bedroom will always provide the most joy. While the photographs I now take are no longer of famous people and entertainers, I take pride and delight in my favorite subjects—my wife, Beulah; my two daughters, Sandy and Judy; my four grandchildren; and the rest of my wonderful family and friends. They are why I exist. "Just one more," I tell them. "Wet your lips, smile, be happy." I love them all. Thanks for listening.

IRVING HABERMAN: A LIFE IN PHOTOGRAPHY BY MILES BARTH

The ability to visually document ourselves has significantly changed the course of our world and the way we see, public and private, past and present, yielding an unprecedented record of human activity. Historic twentieth-century photographs remind us of events that have significantly changed the course of our world, serving as concrete remembrances capable of eliciting a wide range of nostalgic emotions. For more than four decades, Irving Haberman used his cameras and his creative intellect to provide us with an irreplaceable photographic history, a visual data bank of American culture.

Born in the Bronx, New York, on June 1, 1916, Irving Haberman was the fourth of five children. His Russian father and Polish mother had married in Europe, immigrating to this country to start their family. When Haberman was young, his family relocated to Brooklyn, where his father owned a dry-cleaning and tailoring business. Haberman's youngest brother, Henry, would also become a photographer, specializing in fashion and advertising through his studio, Habershore.

The 1920s and 1930s represented a heady time in aviation, with celebrities like Charles Lindbergh and Amelia Earhart setting records and making headlines. Fascinated by this burgeoning mode of transportation, the young Haberman decided he wanted to be a pilot and spent all his spare time at Brooklyn's Floyd Bennett Field. At the age of thirteen, Haberman asked his father for a camera so he could document the activities associated with the planes he so desperately aspired to fly. He received a Kodak folding camera and consequently his first photographs depicted pilots, meets, and races; at the field, Haberman also came into contact with the expanding leagues of press photographers and journalists. In 1932, while Haberman was studying to become a pilot, his teacher, Bill Ulbrich, was killed in a crash. As a result, Haberman lost all interest in pursuing a career as a pilot and that part of his life ended.

Irving Haberman.
Brooklyn, 1934.
High school graduation.
Photograph by the Arthur Studio.

Haberman's high school employed the Arthur Studio to conduct school photography, and when someone from the studio saw Haberman's work in a Midwood

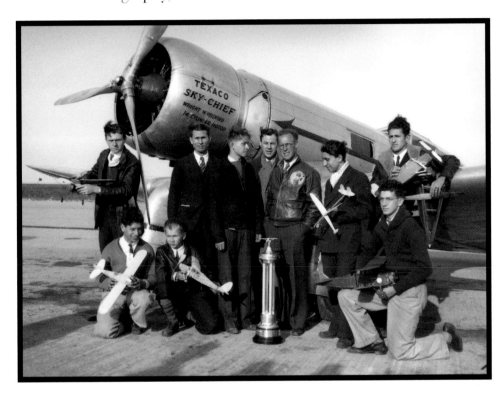

Camera Club display, the studio promptly offered him a job. It had been Haberman's desire during his last years of high school to enter medical school. With no family money for tuition, however, Haberman accepted the position and began working in 1934 after graduat-

Members of the Abraham Lincoln High School Aviation Club at Floyd Bennett Field. Brooklyn, 1930. Photograph by Irving Haberman.

ing from high school. Operating out of New York City, the Arthur Studio specialized in individual and group portraits of students, in the studio and on location. Haberman was comfortable with both the small-format 35-mm roll-film camera (Leica) and with the larger format 4×5" sheet-film camera (Speed Graphic). This versatility allowed him to supplement the stock work he was doing for the Arthur Studio with freelance candid photographs of school activities. The mundane routine of the portrait studio, however, coupled with Haberman's interest in current affairs, convinced

Irving Haberman at the Arthur Studio. New York City, 1935. Photographer unknown.

him that his skill in photography would be better served in a different environment. When Haberman was denied a raise to eighteen dollars a week, he left the Arthur Studio after a two-year tenure. Shortly thereafter Haberman joined the staff of the *Brooklyn Eagle* in 1936, launching a fifty-year career as a news photographer.

Over the course of his career, Haberman distinguished himself with a remarkable breadth of work. Press photography—the making of pictures for periodical publications—divides into three basic categories: "spot" or breaking-news photography, feature photography, and photojournalism; Haberman's ability to excel in all three arenas set him apart.

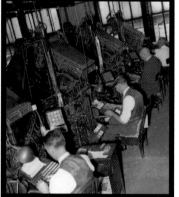

Linotype-Machine Operators Setting Type at the Brooklyn Eagle. 1937. Photograph by Irving Haberman.

The breaking-news photographer is responsible for recording newsworthy events as they occur. News photographers generally work as staff members of publications, dispatched with reporters to cover stories or events. Often breaking-news photographers are not on the scene as an event unfolds and are left to record only the aftermath; many of the published photographs that depict moments of unexpected drama or disaster are caught by amateurs, on the scene by chance as the event occurred. In most cases, news photographers' assignments are of an ongoing or predictable nature, and they must provide the publication with images that clearly and powerfully depict the event, complement the reportage, and visually entice the reader into the story. Haberman's photographs of labor demonstrations and crime are classic examples of this form of coverage (pages 60, 66–69, 102–3).

Feature photography—found, for example, in Sunday supplements and magazine sections of newspapers—allows the photographer to plan a series of pictures that extensively illustrate an event or subject. Features can range from the domestic to the dramatic, and photographers are often summoned from beyond the publication's core staff by virtue of a particular specialty, while more general features might be covered by staff photographers. Haberman's coverage of domestic life during World War II—scrap metal and rubber drives (page 77), women lifeguards (page 79), or convalescing veterans (pages 82–83)—exemplify the extended photo story.

Photojournalism, often used loosely to describe any news photography, is actually the extended photographic treatment of a specific newsworthy topic. Rather than making photographs to augment a text, the photojournalist spearheads the story, lending

the photographs an editorial slant. The text in this case acts as a complement to the pictures. Many photojournalistic essays are initiated by the photographers themselves, later to be proposed for publication. Haberman shaped his documentation of the television medium into photojournalistic form, narrating it with his own texts.

Modern photojournalism began to emerge as a distinctive mode of communication in the 1920s, but its origins can be traced to the mid–nineteenth century. Roger Fenton's Crimean War photographs (1855) and depictions of the Civil War by Mathew Brady and his corps of photographers (1861–65) are generally regarded as the first major reportage-documentary uses of the medium.

The slow evolution of photojournalism, however, can be attributed to technical and cultural delays. Through World War I, government agencies exercised a fairly substantial degree of censorship, prohibiting publications from freely illustrating certain topics or events. It was not until the 1920s that several landmark legal cases upheld the notion of the free press, allowing these publications more credibility in their ability to document current affairs. In the technological arena, advances in reproduction lagged behind photographic capabilities. In 1880, the first use of the halftone process allowed the *New York Daily Graphic* to reproduce a picture of shanties in New York City's Central Park, marking the first direct reproduction of a photograph in a newspaper without hand-copying or engraving. The halftone divides the image into tiny elements—dots or lines— that deposit ink in proportion to the strength of the original tones in the image. Improvements in the halftone processes in the 1880s and 1890s expanded the use of journalistic photographs and began to bring a new veracity to periodical illustrations, laying the foundation for the truly visual mode of reporting that appeared after World War I.

Irving Haberman on Assignment for the Brooklyn Eagle. 1938. Photographer unknown.

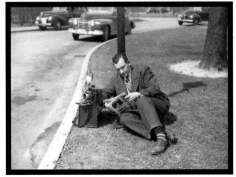

As documented by this book, Haberman's photographic versatility leaves us with an unparalleled history of four decades of American life. While many of his photographic

contemporaries in the 1930s were preoccupied with documenting the ravages of the Great Depression, some under the auspices of Roosevelt's Farm Security Administration, there were only a handful of photographers who addressed life in large cities. Haberman's work establishes him as a dominant force among photographers who specialized in the urban environment.

When Haberman joined the *Brooklyn Eagle* in 1936, the paper, with its circulation of over one hundred thousand, was one of two major daily newspapers in Brooklyn and was known for its fierce loyalty to New York's most populous borough. The *Eagle* afforded wide distribution for Haberman's photography and freed him to pursue a variety of subjects. Haberman's large frame—he stood 6'2" and weighed 230 pounds—allowed him to undertake stories that required an extra measure of strength. The paper directed him to sporting events, labor strikes and disputes, crime scenes, and street demonstrations; strenuous or hazardous activities became Haberman's specialty, and he received numerous citations for his work.

After two years on the *Brooklyn Eagle* staff, Haberman left to pursue the reputedly better money of freelance photography and, at the urging of his *Eagle* colleagues, opened his own one-man photo syndication, Newsphotos, Inc. Located in an office across the street from the Brooklyn police headquarters, Newsphotos, Inc., permitted Haberman easy access to breaking crime stories. Only recently repealed, Prohibition had heightened the activities of organized crime, while large groups of European immigrants who arrived in the 1910s and 1920s fought amongst themselves for survival. Hollywood and the film-going public's fascination with crime translated to journalism as well—crime was everywhere, and it was subject matter that sold newspapers during the late 1930s.

While on the *Brooklyn Eagle* staff, Haberman had formed a close association with William O'Dwyer, the Brooklyn district attorney, who later would become mayor of New York City. As district attorney, O'Dwyer concentrated on Murder, Inc., the notorious, Brooklyn-based arm

Irving Haberman at Newsphotos, Inc. Brooklyn, 1939. Photographer unknown.

of organized crime that employed killers and promoted their services to other crime organizations across the country. During his Newsphotos, Inc., period, Haberman worked the 6:00 P.M. to 8:00 A.M. shift out of the Brooklyn police headquarters, documenting O'Dwyer's crime beat. Like Weegee (Arthur Fellig), his future colleague at the newspaper *PM*, Haberman was given access to information, crime scenes, evidence, and news before the other press photographers.

With the outbreak of World War II, local news and crime photography was overshadowed by news from Europe and reports on American reactions to the war. Although Haberman had applied to both the army and its air corps, he was rejected for a severe hearing problem. Early in 1941 Haberman used the money he had made free-lancing and married Beulah Workman. That same year, he closed his one-man syndicate and joined the staff of the young *PM*, where he had been freelancing since its 1940 inception.

Irving Haberman Covering Army War Maneuvers at Fort Tilden. Queens, 1940. Photographer unknown.

PM had been created by publisher Ralph Ingersoll, a maverick newspaper entrepreneur, and became one of the most popular daily newspapers in New York City with an average circulation of 175,000. Its outstanding staff of writers, editors, illustrators, and photographers made it one of the most highly respected news periodicals of all time. Shortly after its debut issue, a reader wrote to John P. Lewis, the paper's founding managing editor, and asked: "How come, if your paper is the protection and mouthpiece of the laboring working class and the common man, these people who can least afford to have to pay 5 cents for your daily edition or morning edition, while the plutocrat can purchase his *Times* or *Herald Tribune* for 3 cents?" Lewis's response summed up the paper and its founding philosophy: "The price of *PM* on the newsstands is more deeply tied up with the kind of paper *PM* is than in the case of any other paper about which I know. *PM* was started on June 18, 1940, as an experiment in journalism to see if independent journalists, operating without restriction but the limits of their own consciences, could do a better job of getting to the truth about the news. To guarantee this freedom to the men who put

out the paper, it was decided at the time that *PM* would sell no advertising, but would depend for its income only on the man or woman who bought it at the corner newsstand. That doesn't mean that *PM* has an argument with advertising as such. It does mean that we preferred to do business not with advertisers, but with our readers. We preferred to enter journalism without any interests other than journalism—to sell nothing but news, and our opinions of the news, and not to set ourselves up on conventional lines as sellers of advertising space mixed up with the news." Sometimes referred to as the "Phi Beta Kappa" of newspapers, *PM* set a new standard for the illustrated newspaper, as *Life* had redefined the weekly news magazine. Without advertising, *PM*'s distinctive design could incor-

porate more photographs and afford them more space. This emphasis lent the newspaper a prestige that drew important photographers of the time, including Margaret Bourke-White, Morris Engel, Morris Gordon, Helen Leavitt, and Weegee. Haberman was one of the *PM* elite.

By 1948, diminishing revenues and declining readership, in part due to radio and television competition, forced many major New York dailies to abbreviate their formats and, in some cases, to close their operations. In June 1948, *PM* was sold and became the *New York Star*. Under its new name and leadership, the paper added advertising but rapidly lost readers and in January 1949 ceased operation. At the time, *PM* was considered one of the most innovative newspapers in New York City history, a reputation that has not diminished over the years.

Irving Haberman Undercover. New Jersey, 1942. Photographer unknown. Haberman posed as a longshoreman to expose the ease of access to classified military warehouses. After purchasing a union card, he wandered through millions of dollars worth of military stores, writing a story about his experiences for *PM*.

Irving Haberman at PM. New York City, 1943. Photographer unknown.

During the last years of *PM*, Haberman accepted several freelance assignments from Bill Golden, the chief art director of CBS and designer of its "eye" logo. The two became close friends, and in February 1949, in the second year of the network's television operation, Haberman was hired by CBS as a staff photographer.

When he was hired by Bill Golden (at the time director of advertising and promotion at CBS) in February 1949, Haberman was one of only five photographers employed to document the production techniques, technical advances, celebrity activities, news coverage, and other aspects of early television at CBS. Golden immediately assigned Haberman to document the inner workings of network television in order to produce a publication for current and prospective sponsors explaining the network's state-of-the-art production techniques. The publication would hopefully encourage future sponsorship of CBS programming and sell programs to CBS affiliate stations. Haberman's efforts were published in 1949 as *Close-Up: A Picture of Men and Methods that Make CBS Television* (Columbia Broadcasting System: New York, 1949). In its introduction, the book states: "The story is told here for merchants and students, advertisers and actors, technicians and writers—all who see in television many shining possibilities, and want to know more about it."

This early and historic monograph on television was succeeded in 1952 by *Follow-Up: How Creative Production Translated a Point of View about Television into an Important Success Story* (Columbia Broadcasting System: New York, 1952). Illustrated by Haberman's photography, the book documented the beginnings of one of television's most important dramatic series, *Studio One*. In the form of a dialogue, *Follow-Up* presented the various production techniques CBS employed in converting some of the great dramatic theater classics to television. The publication also promoted network services and emphasized television's ability to advertise products and consequently lost its opportunity to critically document early television, becoming a publicity brochure for CBS. Although both books had the design and look of photography publications of the period, neither were sold publicly and were instead distributed as promotional material for CBS.

Because of television, history will never again be quite the same. By putting the viewer on the scene at the moment that news is made or shortly thereafter, television is transforming history from something we read about into something that happens to us, involves us, and becomes a permanent part of us through our participation.

—Richard W. Jencks, president, CBS Broadcast Group, CBS annual report, 1968

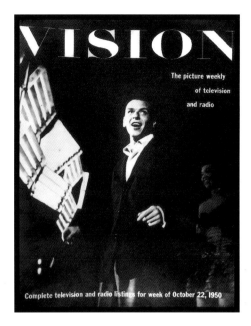

Haberman's commitment to television and its photographic documentation inspired him in October 1950, with partner Mort Rubenstein, an art director at CBS, to produce a prototype for a weekly television magazine. The magazine was to be the first devoted to television news and schedules, and would feature stories on celebrities and future programming, also providing day-by-day television calendars. Calling their creation *Vision: The Picture Weekly of Tele-*

Cover Prototype for Vision. 1950. *vision and Radio*, the two men secured the primary financial backing of businessman Louis S. Weiss. A few days before the final prototype was to be presented, Rubenstein happened upon Weiss's obituary in the newspaper while riding home on the train. Unable to find other investors, the project folded, never progressing beyond the pilot stage. The idea was perhaps ahead of its time; on April 3, 1953, the first issue of *TV Guide* hit the newsstands with an almost identical format, and within a year the magazine boasted a circulation of 1.5 million.

Producing full-length photojournalistic stories of television's early days while enjoying the opportunity to join news crews on assignment, Haberman found himself in a rare position. CBS encouraged Haberman to cover everything involving television news and network production. Subjects included Nikita Khrushchev's trip through the United States; Eisenhower's travels through Europe and India; all manned Cape Canaveral (called Cape Kennedy from 1963 to 1973) space flights; every major political convention from 1949 to 1986; important studio events such as Edward R. Murrow's *See It Now* episode on Senator Joseph McCarthy, and the 1960 John F. Kennedy–Richard Nixon television debate (for which he was the only photographer allowed on the set); and the CBS reenactment of the Warren Commission's report on the assassination of President Kennedy.

Haberman became friends with many of the celebrities, news personalities, and politicians who appeared on CBS. On occasion, at the request of the advertising and

promotion departments, Haberman would produce extended stories, organized into the form of personal photo albums. Subjects included Edward R. Murrow (page 134), the Kennedy family (pages 160–61), Lucille Ball (page 162), and Jackie Gleason (page 164). These albums incorporated an introductory text, handwritten by Haberman, that contextualized the photographs and expressed his affection for his subjects. One copy of these albums was given to its respective subject, while another copy was retained for the CBS archives. The albums served as a token of the network's gratitude for the personalities' cooperation with and endorsement of CBS activities.

In 1968 Haberman took a leave of absence from CBS to serve as Richard Nixon's official presidential campaign photographer (page 173); after Nixon's victory, he was asked to stay with the Nixon adminstration, but preferred his CBS duties and returned to his position with the network. For thirty-seven years, Irving Haberman was a pioneering photographer at CBS, injecting style and humanity into the formerly posed depiction of celebrity and television affairs.

Over the course of his fifty-year career, tens of thousands of Haberman's photographs have been published in every major American periodical. While his name has not been widely known, in part due to the photographs' anonymous syndication through wire services and other modes of photojournalistic distribution, his images are immediately familiar. He has received over seventy awards and citations and is still a member of both the New York and National Press Photographers Associations. Remembered by former colleagues as a selfless individual and good friend, his generosity extends to the visual record he created. Haberman's ample and expressive work allows us to live or relive the era he so thoroughly and compassionately documented.

Sid Caesar, Irving Haberman, and Audrey Meadows.
New Rochelle, New York, 1965.
Photograph by Irving Haberman.

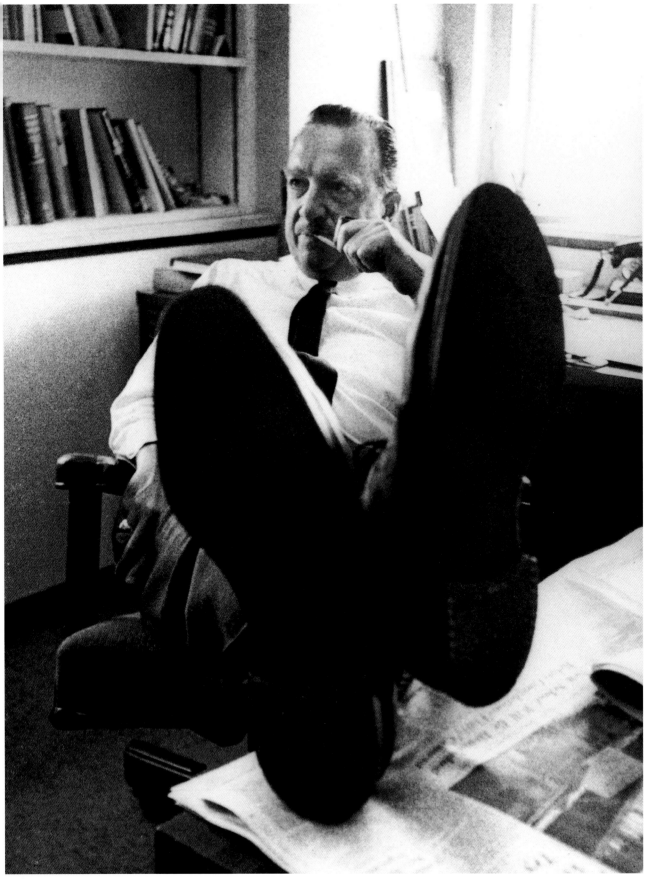

A little more than a hundred years ago, the painter James McNeill Whistler wrote: "If the man who paints only the tree, or flower, or other surface he sees before him were an artist, the king of artists would be the photographer. It is for the artist to do something beyond this: in portrait painting to put on canvas something more than the face the model wears for that one day; to paint the man, in short, as well as his features."

Throughout a career that has covered more than half a century, Irving Haberman has proven that he was more than a photographer who simply covered the historical events and personalities of his time (and mine, for that matter), although that is what has defined him. It is clear from his results that Irving Haberman was an artist, with lens and camera as his tools. He had a fine eye for character as well as composition; we at CBS always felt very lucky to have him.

I first met Irving when he was assigned to cover the work of CBS News. Over the course of his time at CBS—thirty-six years—he became a very good friend of mine. His job was to document the reporting of history, and he did so with considerable aplomb. Irv seemed to meld into the news coverage itself. Clearly his physical presence (at 6'2" he cast a formidable shadow) was noticeable, but he was not obtrusive, absolutely a member of the team.

It is the gift of the photographer to present us with an unedited eye on ourselves, to offer us the opportunity to step back and examine truths we hold from a distance, to understand and reaffirm, or to evoke change. Throughout his career, Irving has captured the events and personalities that have defined our times, and consequently has painted a picture that transcends the actual moment and fills the pages of our history books for future generations.

There is no question that life is cyclical—as our personal lives are, so is our national life. One of the great problems with those who grow older

in the news business lies in retaining any kind of freshness and viewpoint when we experience this sort of déjà vu from every kind of story that crosses the desk. You will find, in looking through these pages, that the actions of people tend to be quite similar over time. Thinking in terms of decades is only a matter of historical convenience. The issues that faced our country in the 1930s in many ways parallel those we face today.

As there always have been dichotomies of politics and race, there always have been dreams of a better life and the angst of teens in trouble. There always have been those who have and those who need, as there always have been those who strive and those who simply take. There always will be personalities who dominate the news from all walks of life, from entertainment to religion. Each successive generation falsely believes itself to be the first to endure the trials and tribulations that are part of life's growing process. Education is, for the most part, learning that you are not the first, nor will you be the last. That is why it is important for us—of any age—to see and learn from the photographs included in this book. In the lives and captured moments of others, we will see our past, our present, and our future, and if we may glean just a little insight, we will be so much better for it.

"History is the witness that testifies to the passing of time," said the Roman statesman and philosopher Marcus Tullius Cicero. "It illuminates reality, vitalizes memory, provides guidance in daily life, and brings us tidings of antiquity." Irving Haberman was a still photographer documenting the evolution of a medium—television—that was designed to make him unnecessary, and he did it with a passion and an intuitive eye that make his work timeless.

For more than fifty years, Irving Haberman used his camera to paint the man as well as his features. What follows is history both public and private—the heroes, villains, and times as captured through his lens.

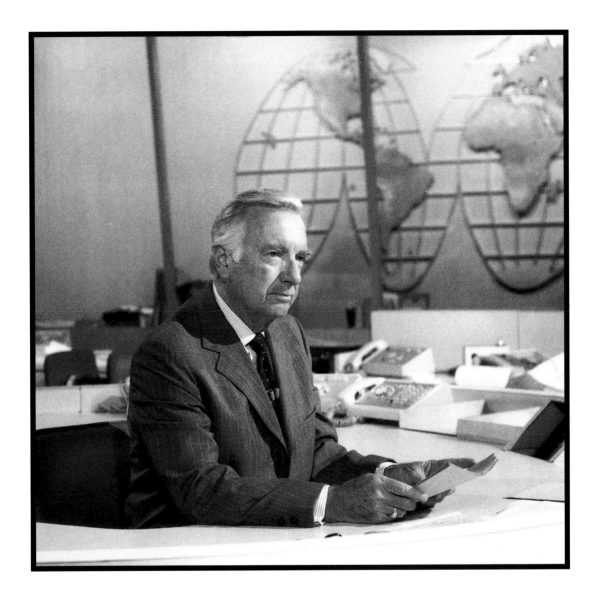

Walter Cronkite on the CBS Evening News *Set.*
New York City, 1978.
Photograph by Irving Haberman.

19

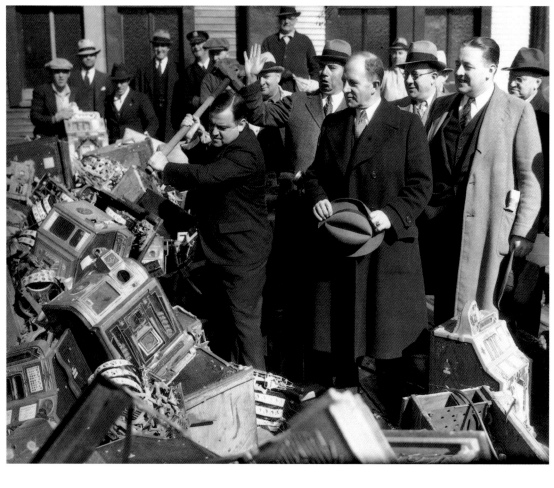

THE 1930s Those who lived through the 1930s and the Great Depression will always be somewhat defined by the individual and collective tribulation of the time. We entered the decade with domestic economic anxieties and we left it with concerns for world security, wondering whether we were going to get involved in this war in Europe.

There is a mysterious cycle in human events. To some generations much is given. Of others much is expected.

The homelessness that now plagues us has strong roots in this period, when millions of men, women, and children were forced from their homes in a nation insolvent. The nation called for reform. The excesses of New York City's Tammany Hall during this troubled time gave way to the changes promised by "the Little Flower," Fiorello La Guardia, a stout and driven mayor who smashed slot machines in the streets and read the funnies over the radio during a newspaper strike.

This generation of Americans has a rendezvous with destiny. —President Franklin Delano Roosevelt, 1936

In with La Guardia in 1933 came President Franklin Delano Roosevelt, who brought the end of Prohibition to a thirsty nation and engineered the New Deal with its revolutionary social legislation. Then, as now, there were dictators—Adolf Hitler and his Third Reich—and salacious celebrity cases, like the Hauptmann trial following the Lindbergh kidnapping. But if you believe, as I do, that what does not kill us makes us stronger, then the ordeals of the 1930s may well be responsible for instilling much of the drive and determination that make America great today. —Walter Cronkite

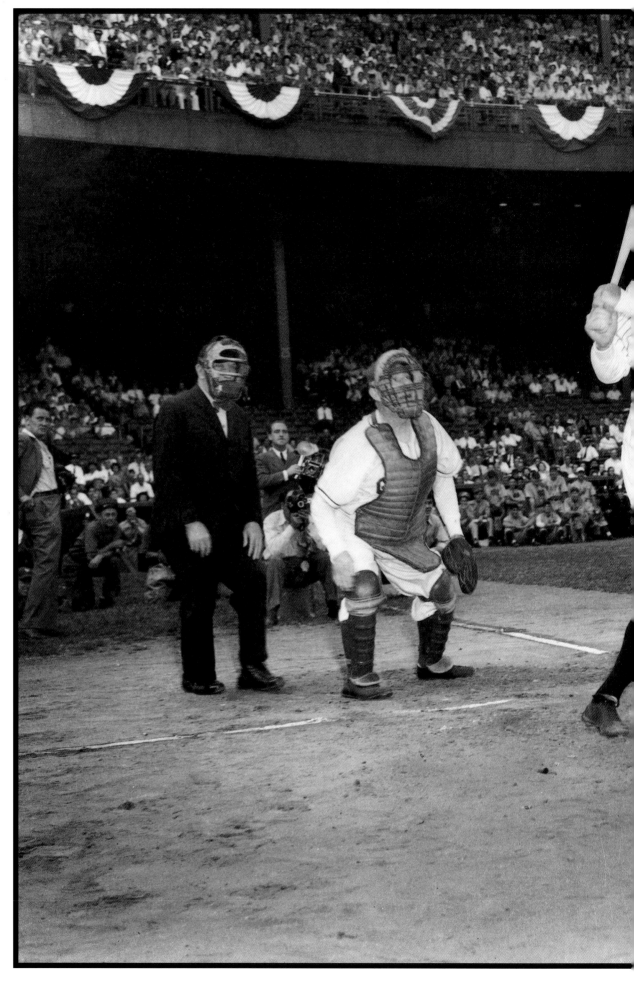

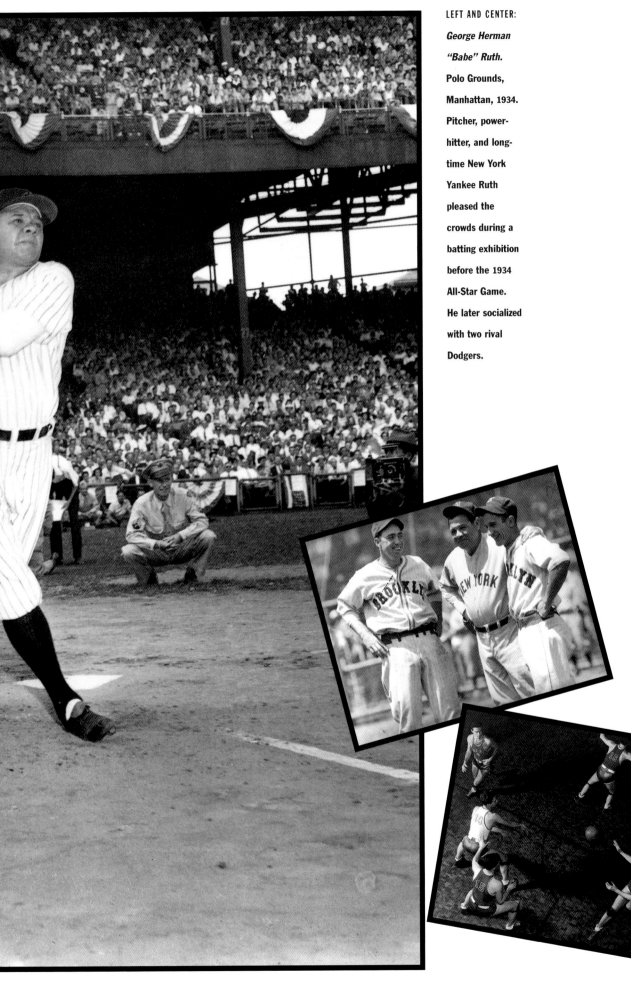

LEFT AND CENTER:

George Herman
"Babe" Ruth.
Polo Grounds,
Manhattan, 1934.
Pitcher, power-
hitter, and long-
time New York
Yankee Ruth
pleased the
crowds during a
batting exhibition
before the 1934
All-Star Game.
He later socialized
with two rival
Dodgers.

BELOW:
Seton Hall
University
Basketball Game.
South Orange,
New Jersey, 1933.

Hobo Convention at the Waldorf-Astoria Hotel. New York City, 1933.

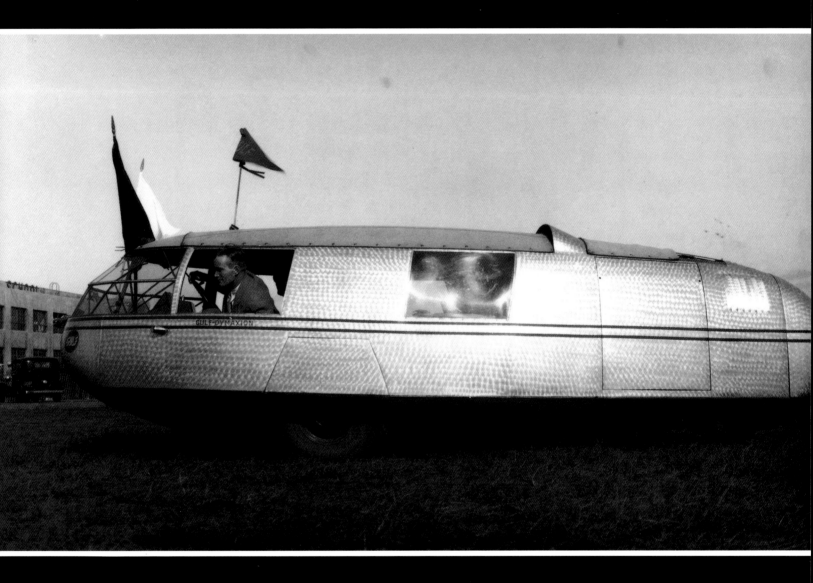

Dymaxion Car. **New York City, 1936.**

With his Dymaxion series, inventor and engineer Buckminster Fuller attempted to solve the Depression-era housing shortage,

bringing mass-production technologies of aircraft and sea vessels to his "Machines for Living" dwellings.

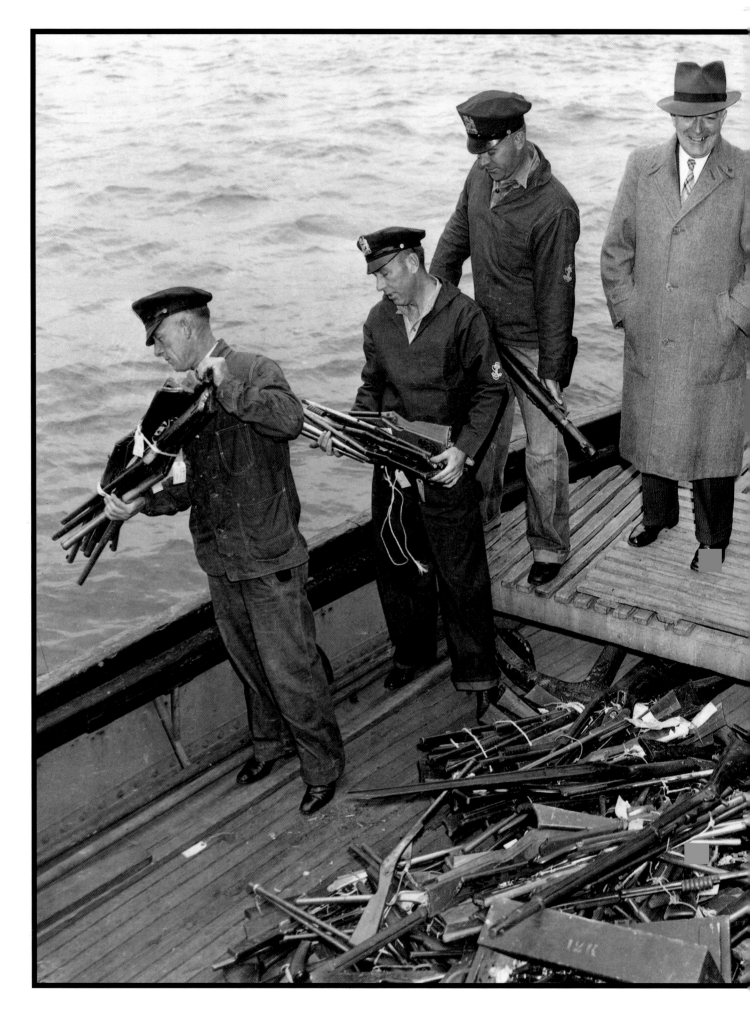

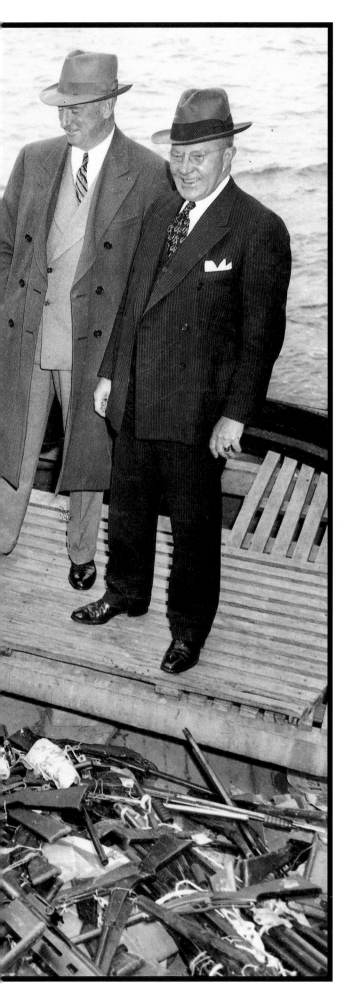

LEFT:

*Police Dump
Confiscated
Weapons at Sea.*
Brooklyn, 1936.

BELOW:

*Bruno Hauptmann
Appeal.* Flemington,
New Jersey, 1936.
The 1932 kidnap-
ping and murder of
aviator Charles
Lindbergh's infant
son shocked the
nation. In 1935,
Hauptmann (center)
was convicted and
sentenced to death;
his appeals were
denied and
Hauptmann was
executed on April 3,
1936.

RIGHT:

St. Louis Cardinals.
Ebbets Field,
Brooklyn, 1937.
They called the
team the "Gas
House Gang," but
these players
dubbed themselves
the "Mudcat
Band." Left to
right: Bob "Lefty"
Weiland, Lon
Warneke, Frenchy
Bordagaray, Bill
"Fiddler" McGee,
Pepper Martin.

BELOW:

Brooklyn Dodgers.
Ebbets Field,
Brooklyn, 1936.

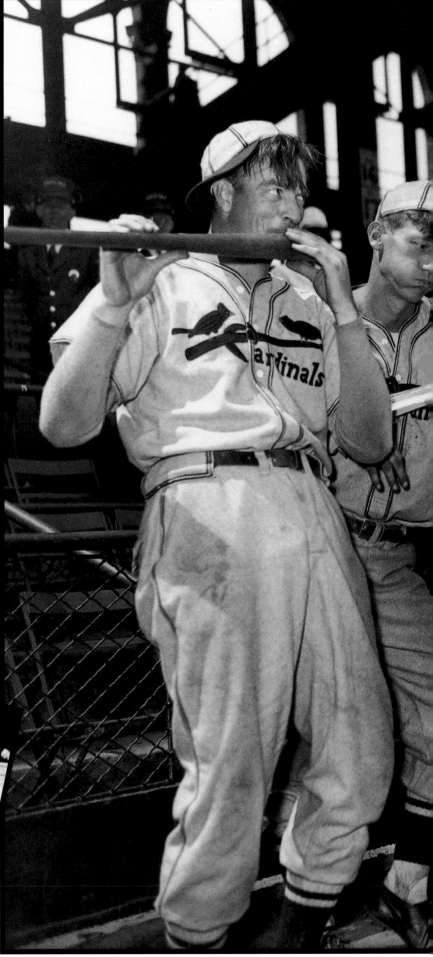

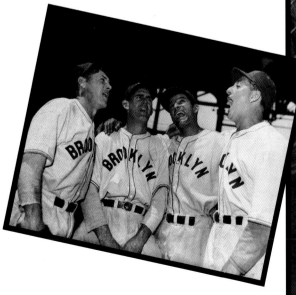

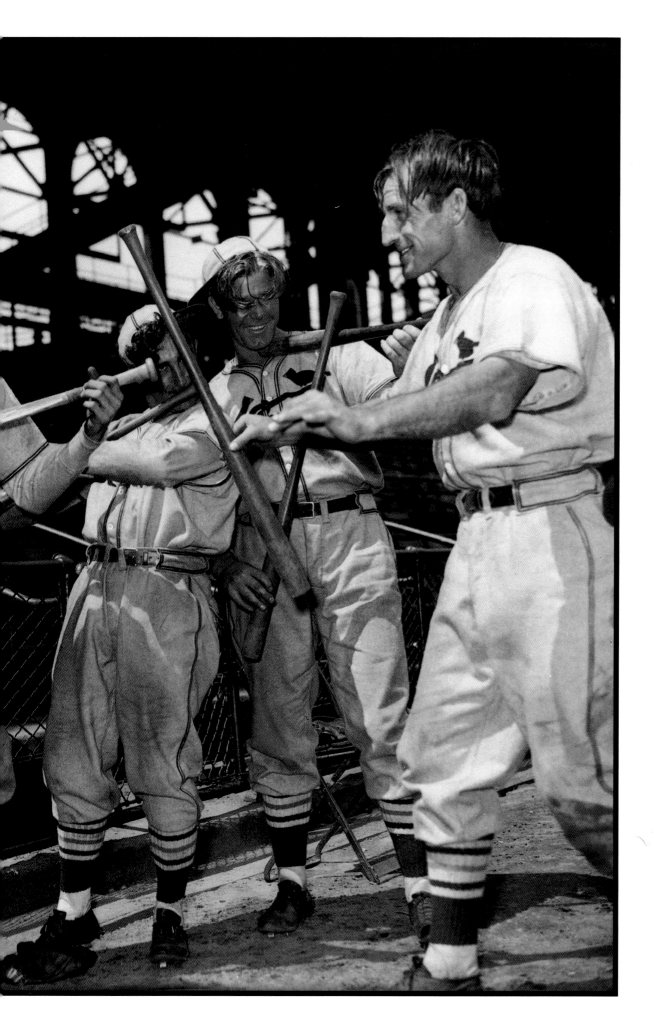

Juvenile Gang Member.

Brooklyn, 1936.

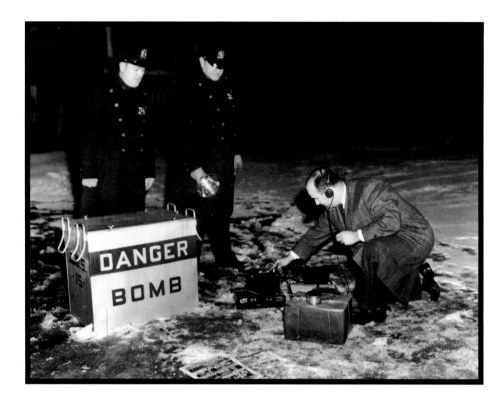

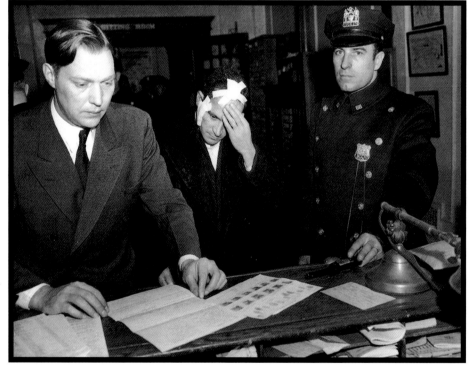

TOP:

Police Defuse Bomb. Brooklyn, 1937.

BOTTOM:

Hold-Up Man Arrested after Milk Bottle Injury. Brooklyn, 1937.

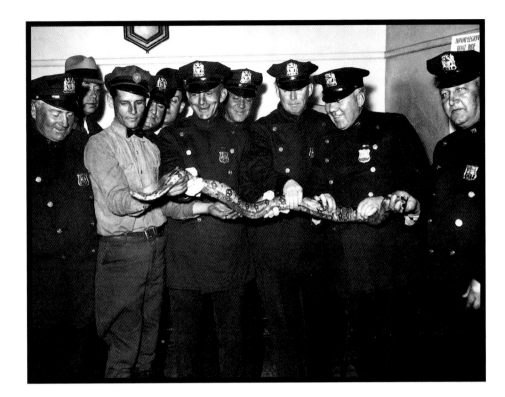

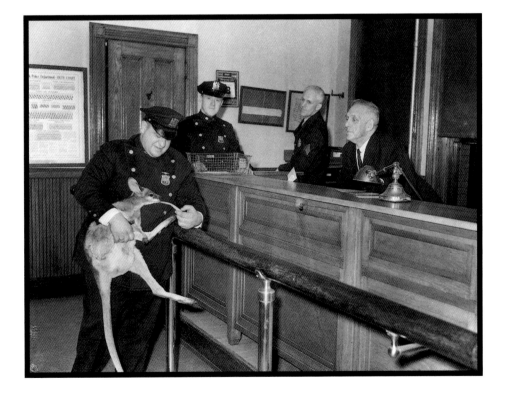

TOP:
Police Capture Escaped Snake. Brooklyn, 1936.

BOTTOM:
Police Find Kangaroo. Brooklyn, 1936.

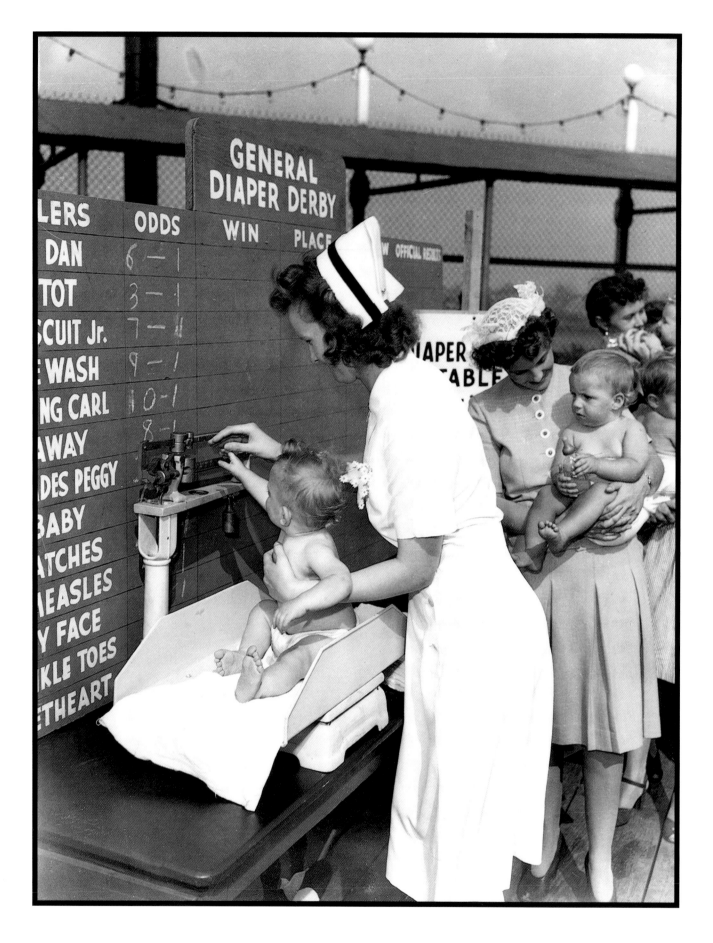

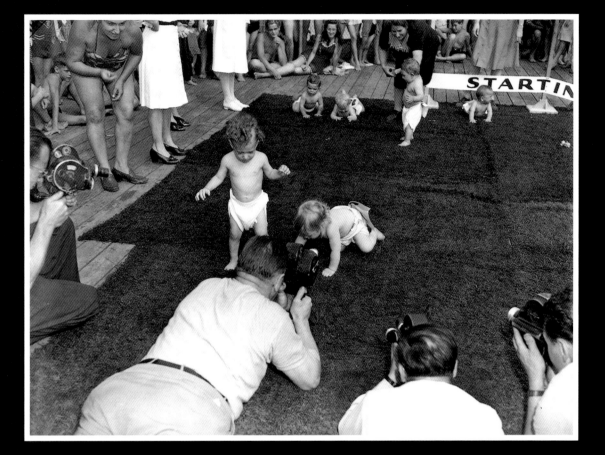

OPPOSITE AND
RIGHT:

Diaper Derby. New
York City, 1937.
These derbies,
popular in the
1930s and 1940s,
were generally
sponsored by
diaper laundries
or soap manufac-
turers. After
weighing in,
babies raced to
win diaper service
or detergent.

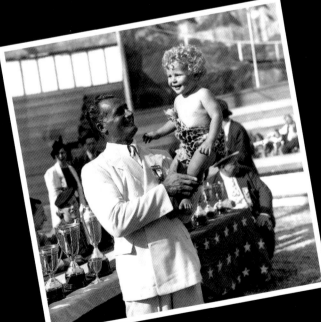

ABOVE:

*Health Contest
Winner.* New York
City, 1937.

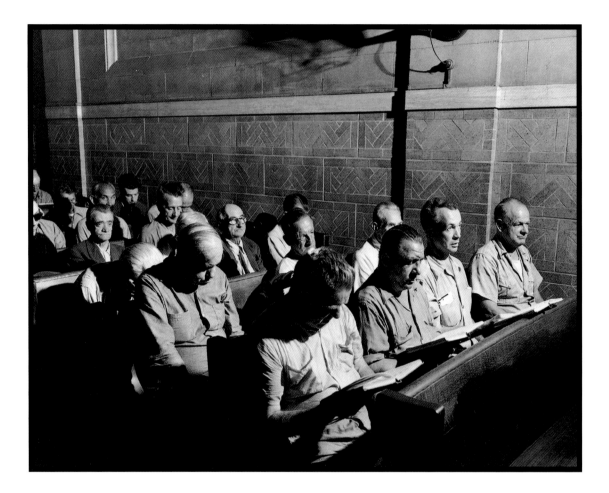

ABOVE AND OPPOSITE: *Bowery Mission.* New York City, 1937.

Notorious for cheap bars and homeless derelicts (giving rise to the term *Bowery bum*),

the Bowery was also home to soup kitchens and other social services.

Buddhist Farmers. New Jersey, 1937.

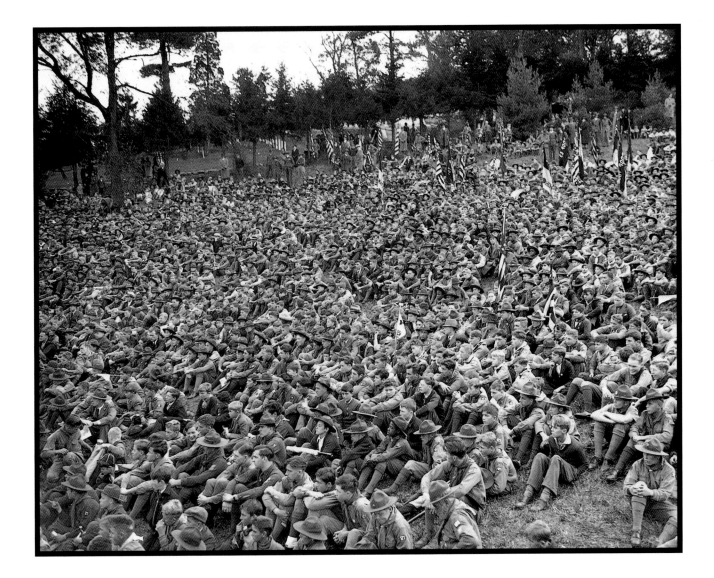

Boy Scout Rally. Brooklyn, 1938.

TOP:

Fiorello La Guardia.
New York City,
1939.
La Guardia's
mayoral duties
included presiding
over this City Hall
rodeo.

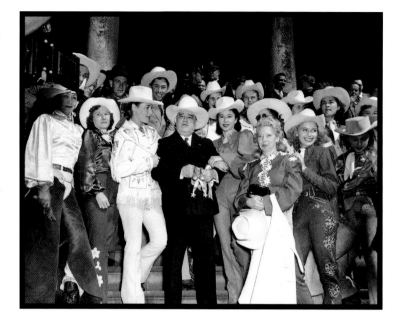

BOTTOM:

*Franklin Delano
Roosevelt, Fiorello
La Guardia, and
Eleanor Roosevelt.*
Hyde Park, New
York, 1938.
During the New
Deal years, Mayor
La Guardia (seated
with cigar) often
paid informal visits
to the Roosevelts'
Hyde Park estate.

BELOW: *Hitler Effigy.* New York City, 1938. As German warplanes helped Fascist general Francisco Franco win the Spanish Civil War, Adolf Hitler joined Austria and Germany under Nazi rule on April 10, the day before this demonstration.

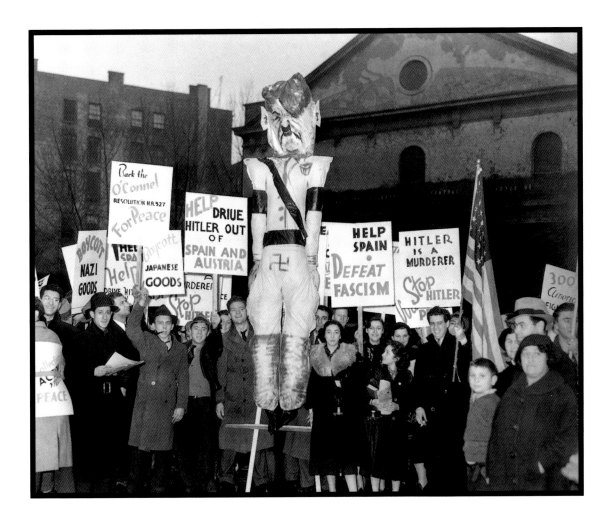

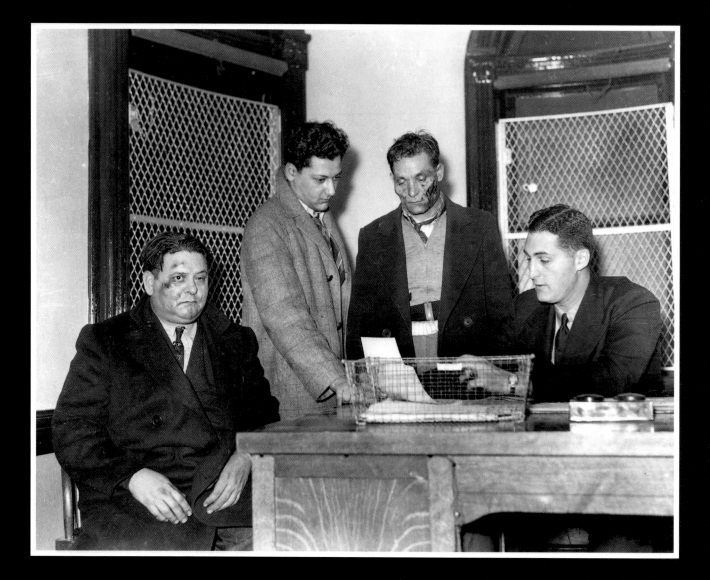

ABOVE: *Hold-Up Men*

Captured. Brooklyn, 1939.

Joe DiMaggio.
Yankee Stadium,
the Bronx, 1939.
The "Yankee
Clipper" took time
after practice to
sign autographs for
admiring fans.

*Franklin Delano
Roosevelt.* Yankee
Stadium, the
Bronx, 1939. The
president threw
out the first ball at
the 1939 All-Star
Game.

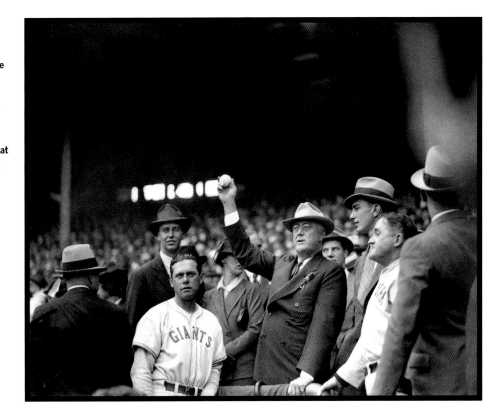

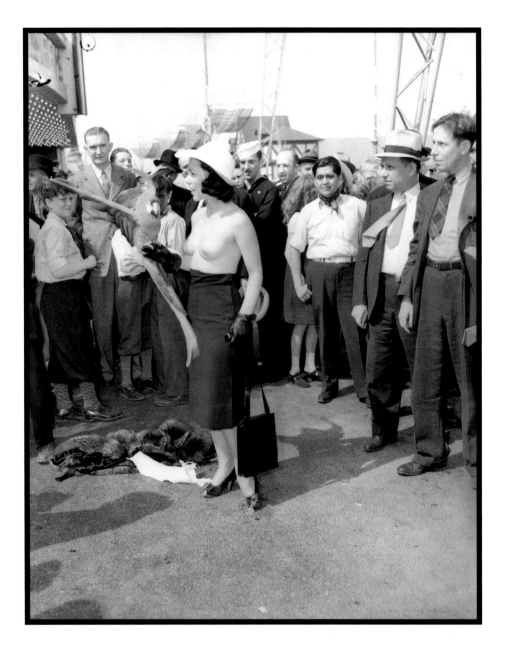

New York World's Fair. Flushing Meadow, Queens, 1939. The "World of Tomorrow" proclaimed progress and peace as its official theme and drew twenty-six million visitors, including radio comedians George Burns and Gracie Allen (opposite) and one errant stripteaser (left).

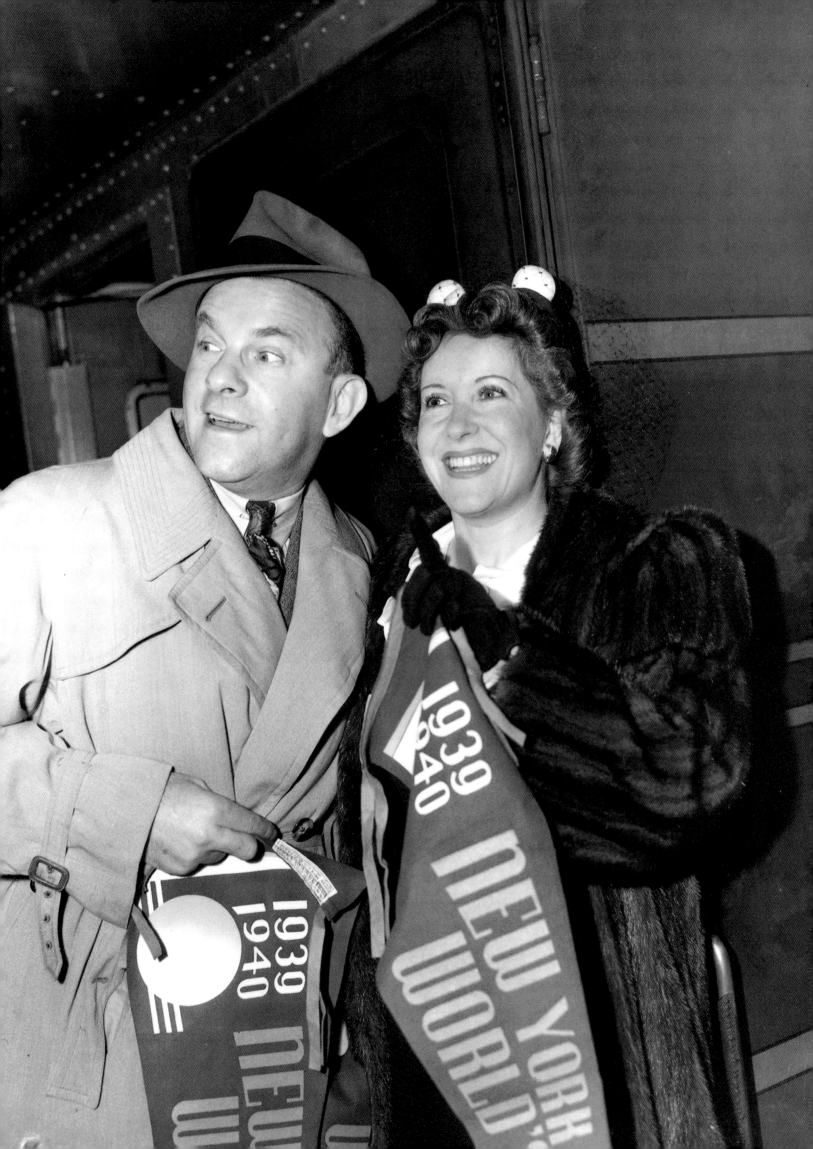

40s

1940

MAY 28 — Holland and Belgium
surrender to Nazis

OCT 24 — Forty-hour work
week goes into
effect in U.S.

OCT 29 — First draft number
drawn in U.S.

1941

JUN 20 — Henry Ford
recognizes UAW

SEP 6 — Nazis require
German Jews to wear
Star of David

DEC 7 — Japanese bomb
Pearl Harbor

1942

MAR 3 — U.S. interns 100,000
Japanese-Americans

JUN 25 — Eisenhower takes
command of U.S.
forces in Europe

NOV 29 — U.S. begins
rationing coffee

1943

SEP 29 — *Mein Kampf*
published in U.S.

OCT 11 — Yankees win
World Series over
Cardinals

DEC 6 — Roosevelt, Churchill,
and Stalin agree on
military strategy

1944

MAY 27 — Sartre's *No Exit*
opens in Paris

JUN 6 — Allied forces land
in Normandy

OCT 9 — Big Four propose
United Nations

1945

MAY 7 — Germany surrenders
unconditionally

JUN 26 — United Nations formed

AUG 6 — Atomic bomb dropped
on Hiroshima

1946

MAR 5 — Churchill warns
of ideological
"iron curtain"

AUG 14 — Joe McCarthy wins
Wisconsin Senate seat

OCT 2 — Smoking said to
cause cancer risk

1947

APR 10 — Jackie Robinson
signs with Brooklyn
Dodgers

JUN 5 — Marshall offers aid
plan for Europe

OCT 14 — Chuck Yeager breaks
sound barrier

1948

JAN 15 — Kinsey report on
sexuality released

AUG 3 — Whittaker Chambers
implicates Alger Hiss

NOV 2 — Truman upsets
Dewey in presidential
election

1949

JAN 10 — RCA introduces
45-rpm record

MAR 18 — Allies organize NATO

SEP 23 — Truman announces
Soviets have
atomic bomb

THE 1940s We were not out of the Depression by 1940 by any means. But soon, in a sort of devil's bargain, the unemployment lines would disappear and help-wanted ads would fill the papers as the country began tooling up for war.

More than any other war in history, this war has been an array of the forces of evil against those of

The decade, of course, was dominated by World War II. It was an effort that required all of us to give all we had. Everybody was involved. There were the millions of us who donned the uniforms, and the millions more who built the weapons they would take to battle. It was an experience of great emotion and intensity for every American. The sacrifice on the home front was shared and the common effort brought us together in a fashion that is exceedingly rare in peacetime. One nation, one people, with one objective. What if we could achieve that to solve some of our problems today?

righteousness. It had to have its leaders and it had to be won—but no matter what the sacrifice, no matter what

Roosevelt did not survive to the conclusion of this second war to end all wars. Vice President Harry Truman finished FDR's third term with an atomic bang and then won his own election with a close victory that defied the pollsters. He beat Governor Thomas E. Dewey, who had first risen to prominence as a tough anticrime prosecutor for New York State and, later, as Manhattan district attorney under La Guardia.

the suffering of populations, no matter what the cost, the war had to be won. —Dwight D. Eisenhower, 1945

With the end of World War II, no longer would the United States favor isolationist policies, for now the world was effectively divided into us and them—democracy against the communist ideologies of our previous wartime allies, the Soviet Union and the People's Republic of China.

Wartime Gasoline Rationing Lines. New York City, 1942. Gasoline rationing went into effect nationwide on December 1 to conserve both gas and tire rubber during the war. Car owners received approximately four gallons per week.

Separationist policies of race relations within our domestic fabric would submit to some dramatic changes as walls began to crack. A stellar athlete and resilient man named Jackie Robinson would become the first Negro player in major-league baseball, paving the way for many to follow, launching future decades of change and progress. Television began to push itself into American homes, crude black-and-white pictures coupled with the sounds already familiar from our radios, creating an entirely new breed of celebrity, forever changing the face of politics, news, and information. Through the public prosecution of former State Department official Alger Hiss, we were introduced to an ambitious young congressman named Richard Milhous Nixon, a man who would mark the political arena for decades to come. —Walter Cronkite

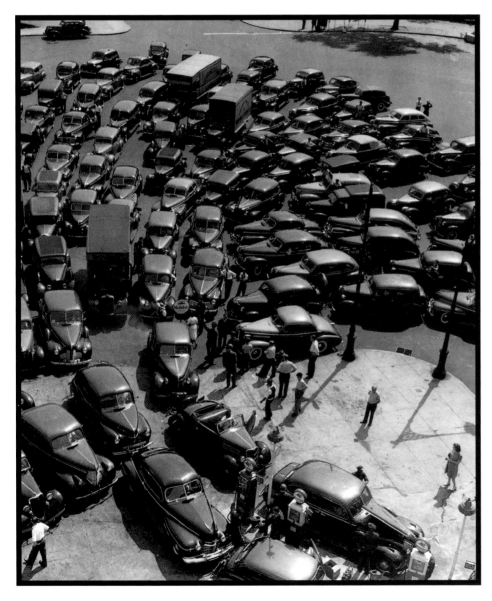

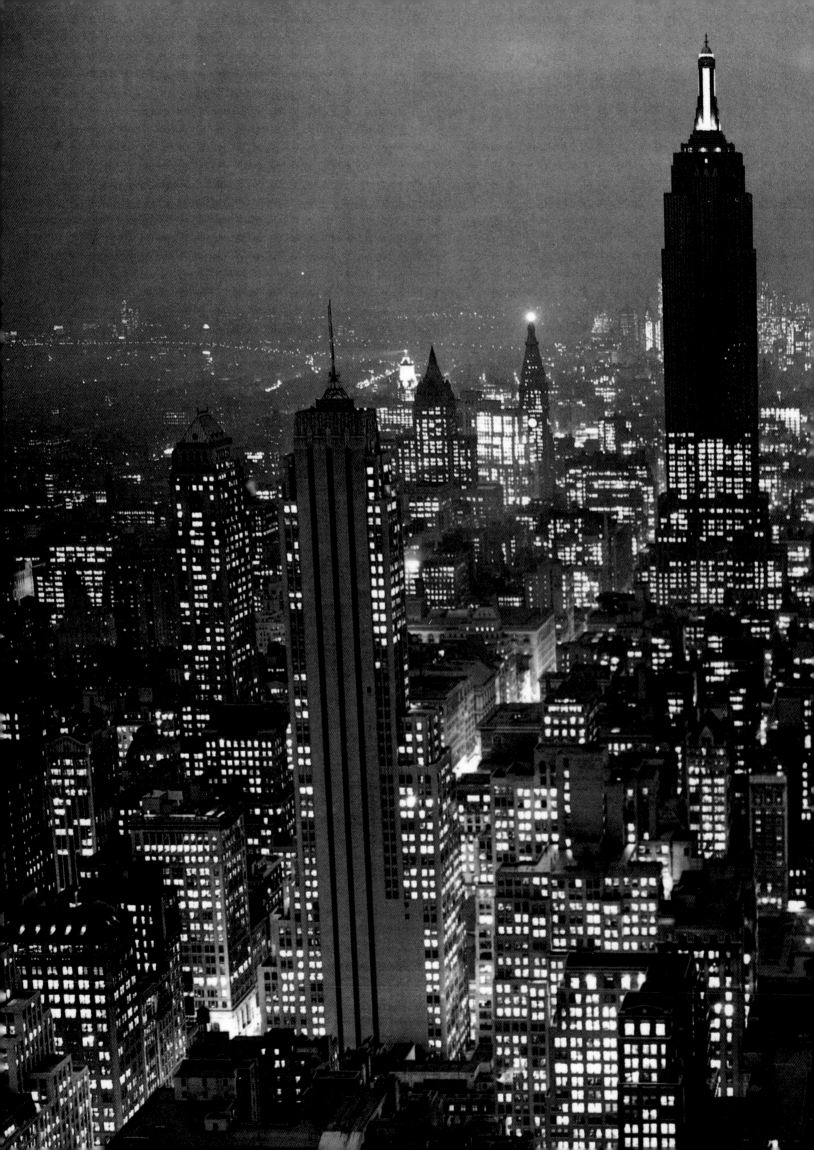

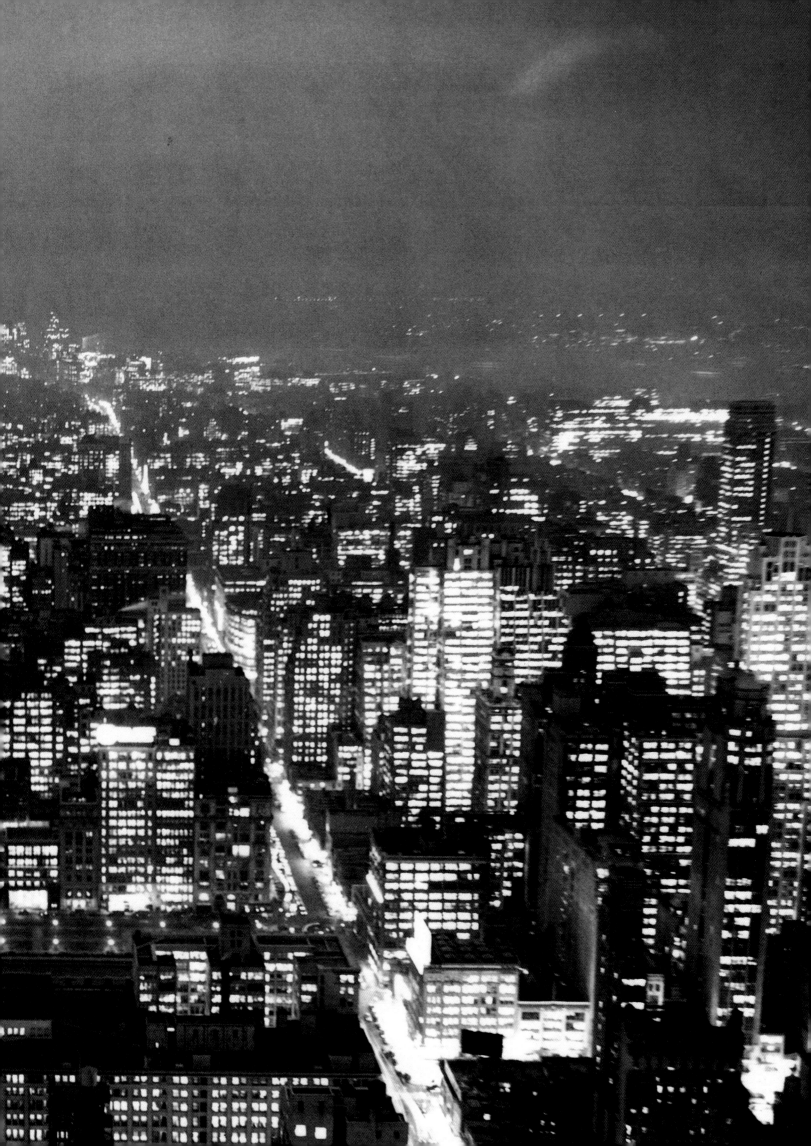

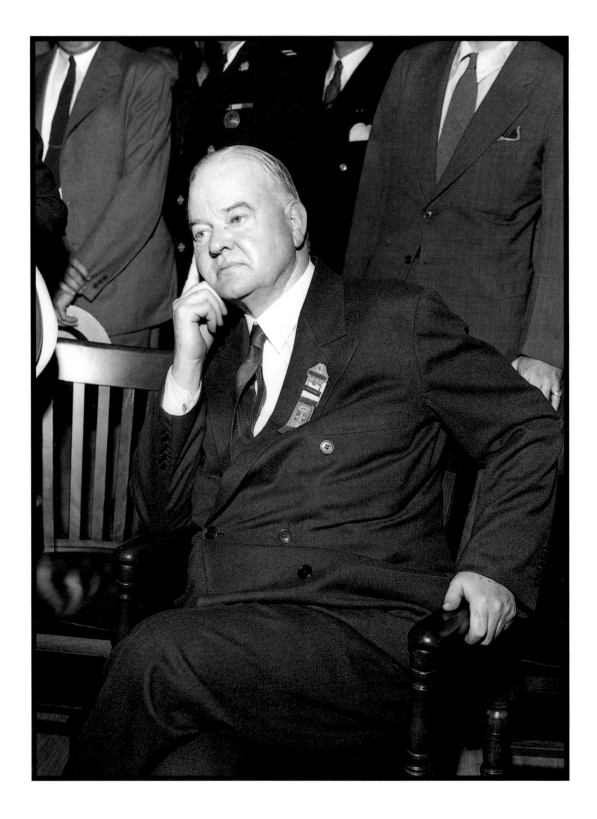

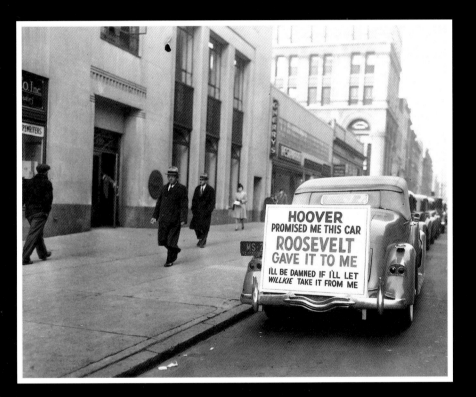

ABOVE:

Roosevelt Gave It

to Me. New York

City, 1940.

Still smarting from

the Depression, one

Democrat car-owner

helped President

Roosevelt win his

third term; Roosevelt

defeated anti–New

Deal businessman

Wendell Willkie.

TOP:

Victim of Murder, Inc.
Brooklyn, 1940.
Murder, Inc., the
Brooklyn-based
enforcement arm of
organized crime, was
infamous for its
particularly brutal
violence.

BOTTOM AND RIGHT:

Murder, Inc., Killers
Leave Sing Sing Prison
for New Trial. Ossining,
New York, 1941.

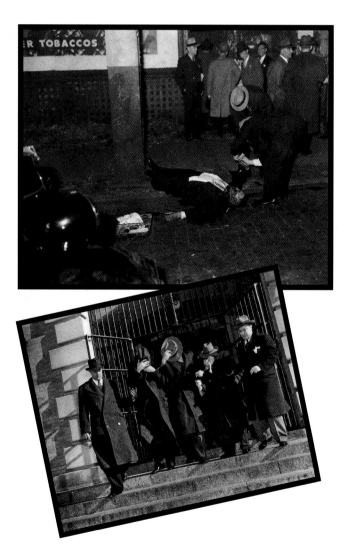

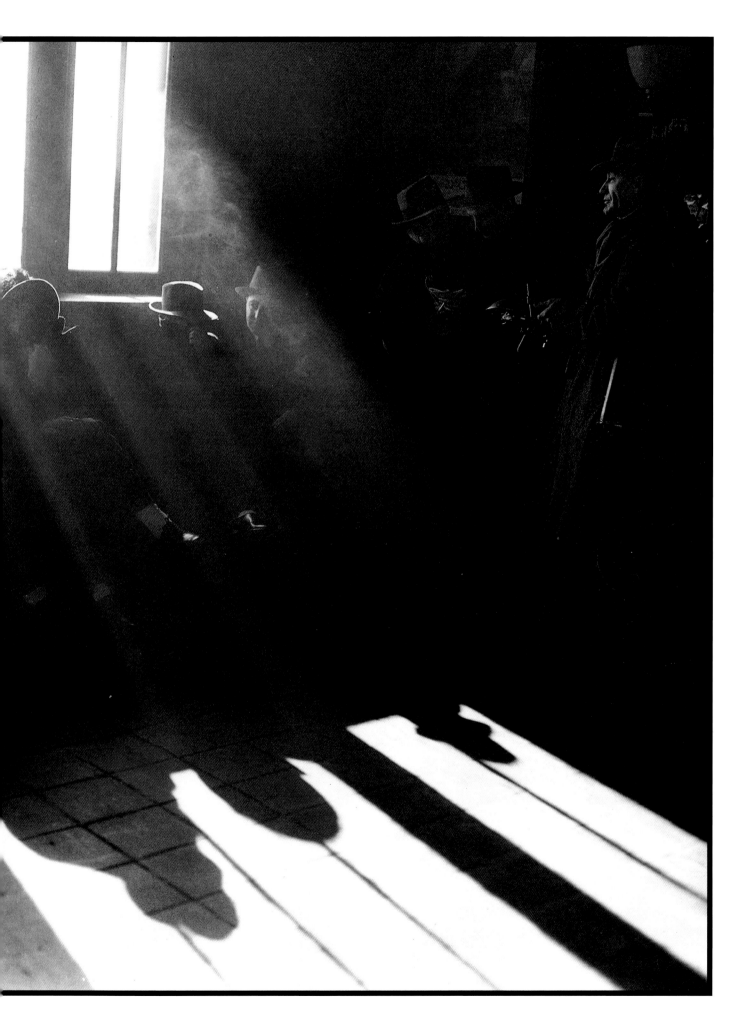

Women's House of Detention.

New York City, 1941.

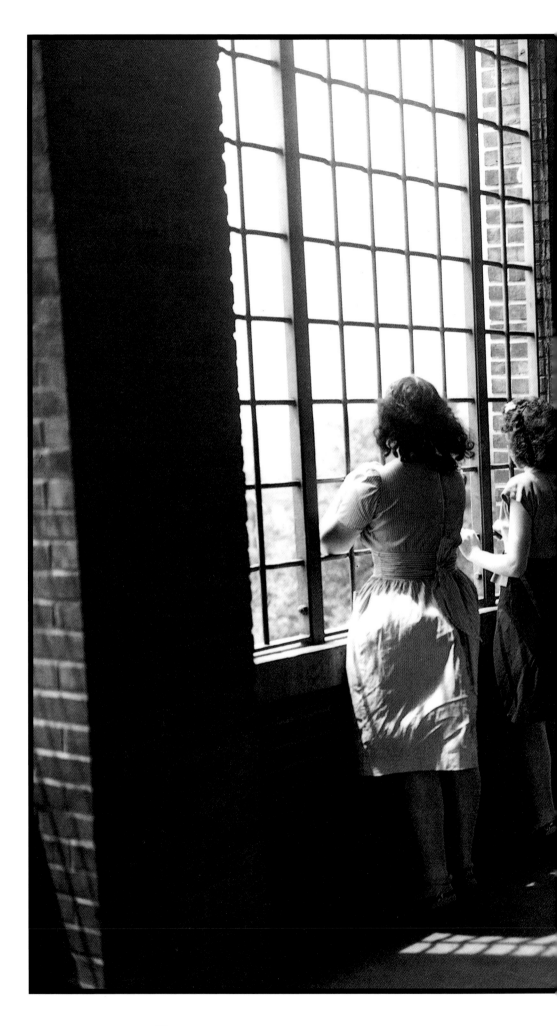

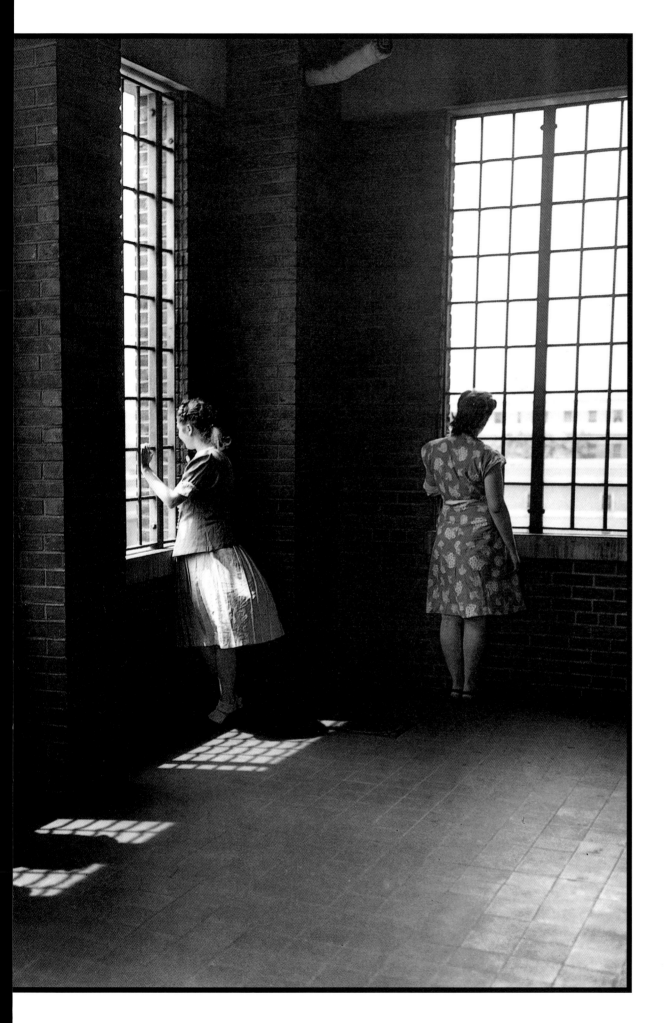

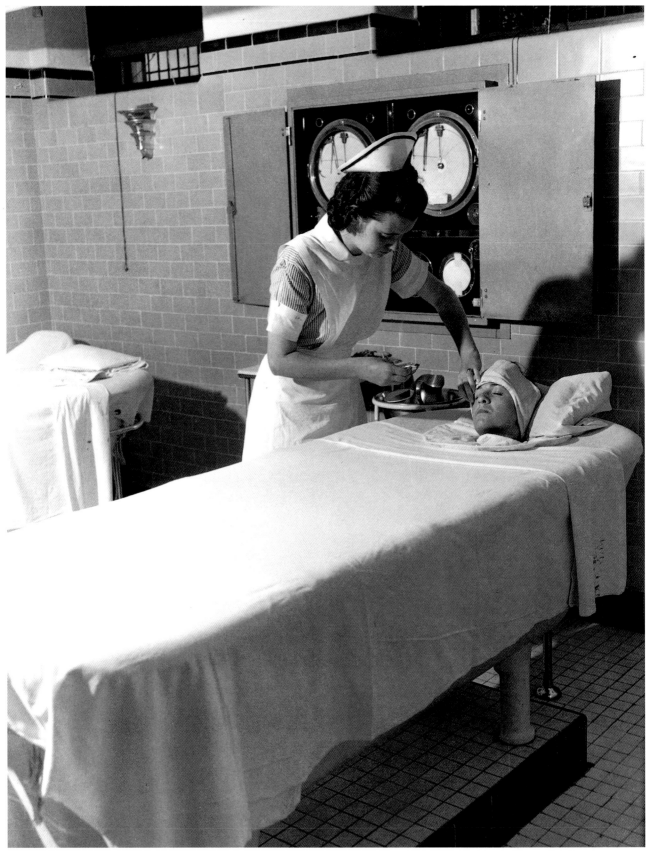

Central Islip State Hospital. Central Islip, New York, 1941.

Treatments at this psychiatric institution included electroshock therapy (opposite). As recreation, patients took part in organized dances (below) or had their hair styled (bottom).

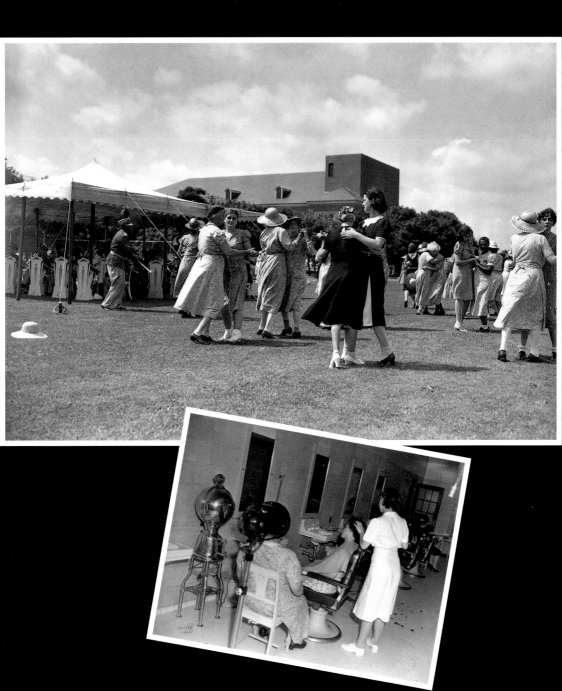

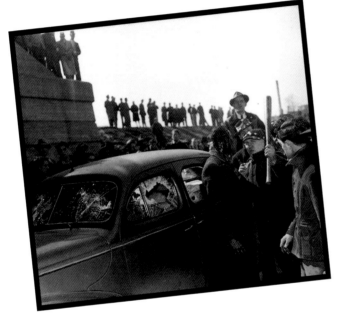

Ford Employees Strike for Recognition of their Union. Detroit, 1941. Two months after this bloody April 11 strike, Henry Ford signed a contract with the United Automobile Workers (UAW), recognizing it as a CIO union, affecting 130,000 workers across the country.

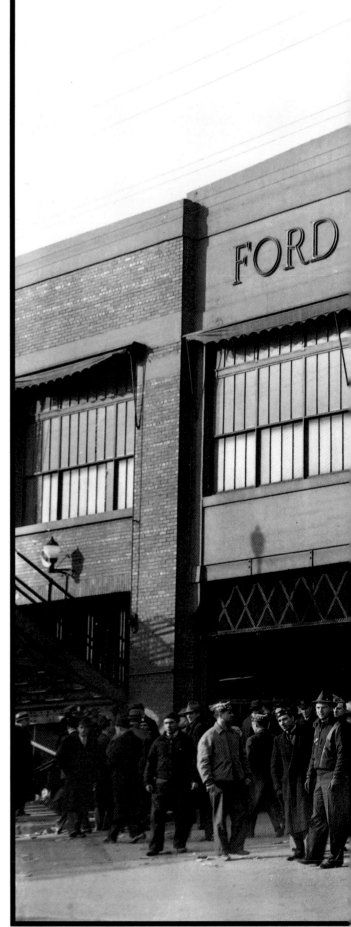

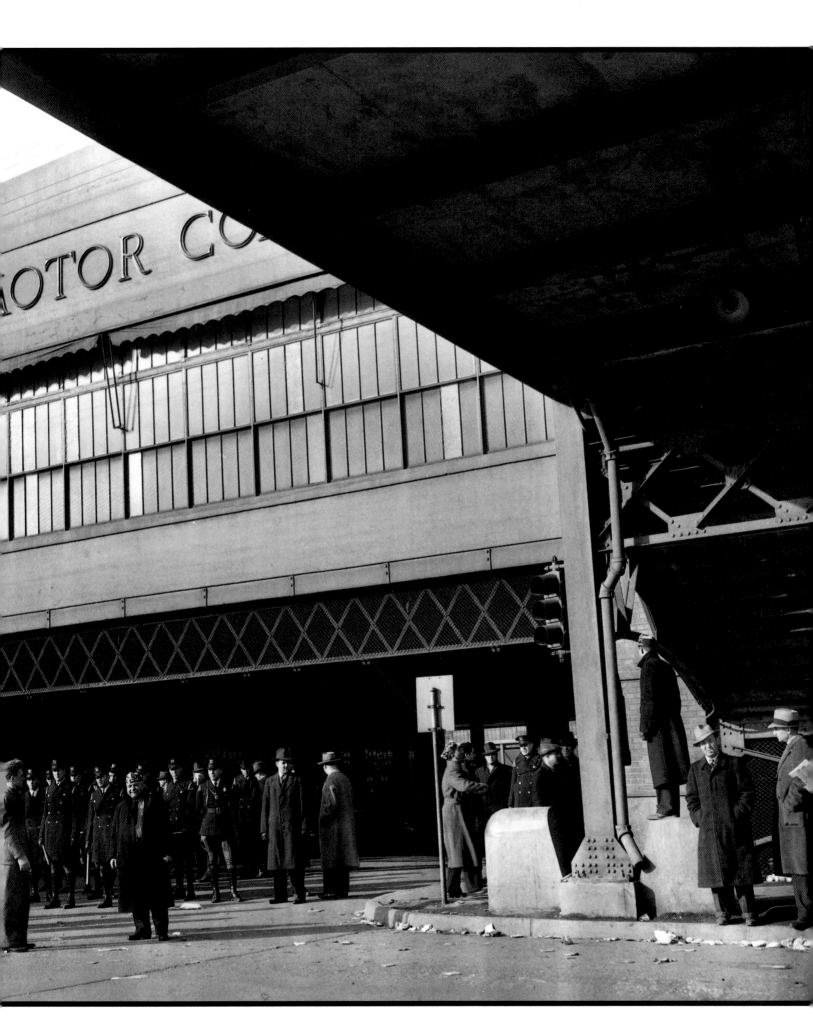

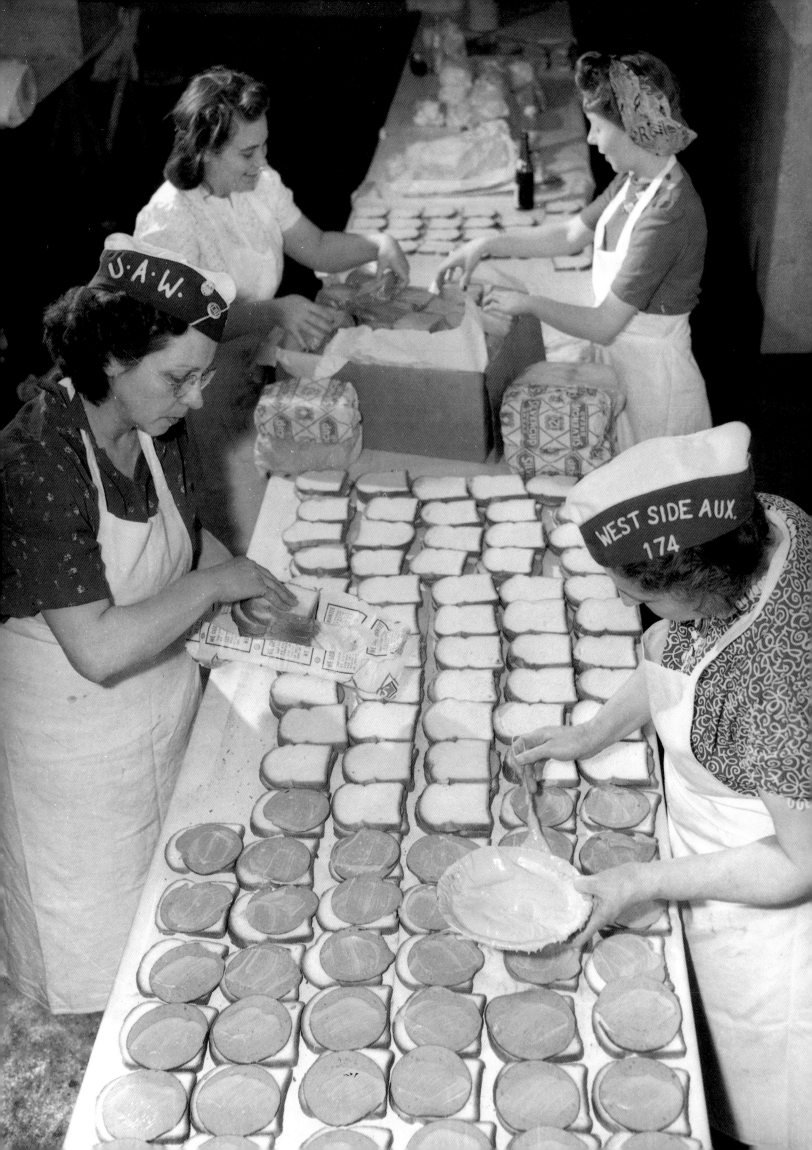

Striking Ford Employees (bottom) *and their Supporters* (opposite and below). Detroit, 1941.

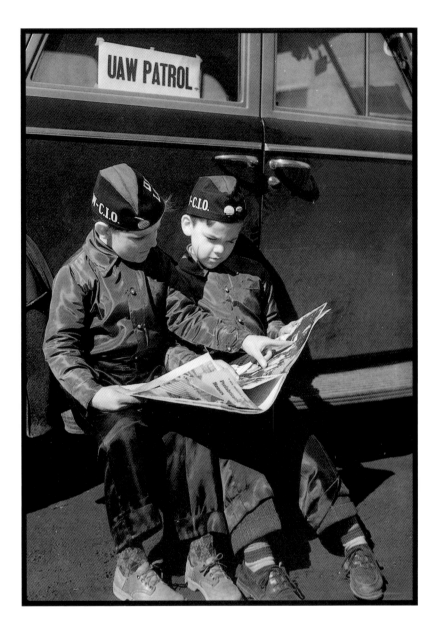

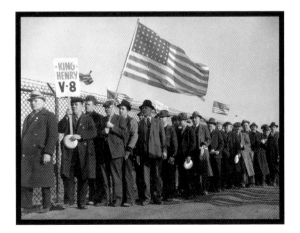

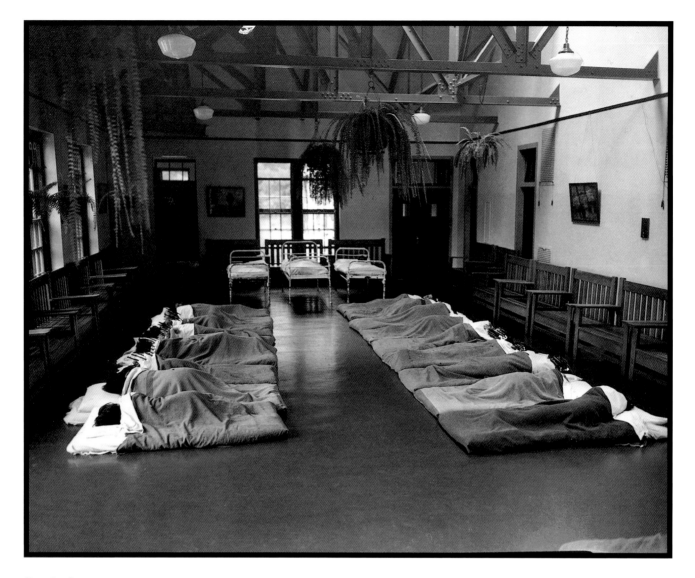

Home for the
Retarded.
New York, 1941.

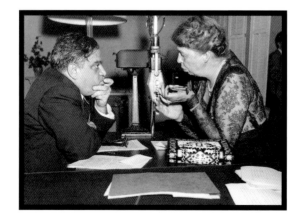

Fiorello La Guardia
and Eleanor
Roosevelt. New
York City, 1941.
Mayor La Guardia
interviewed the
First Lady for his
weekly radio show.

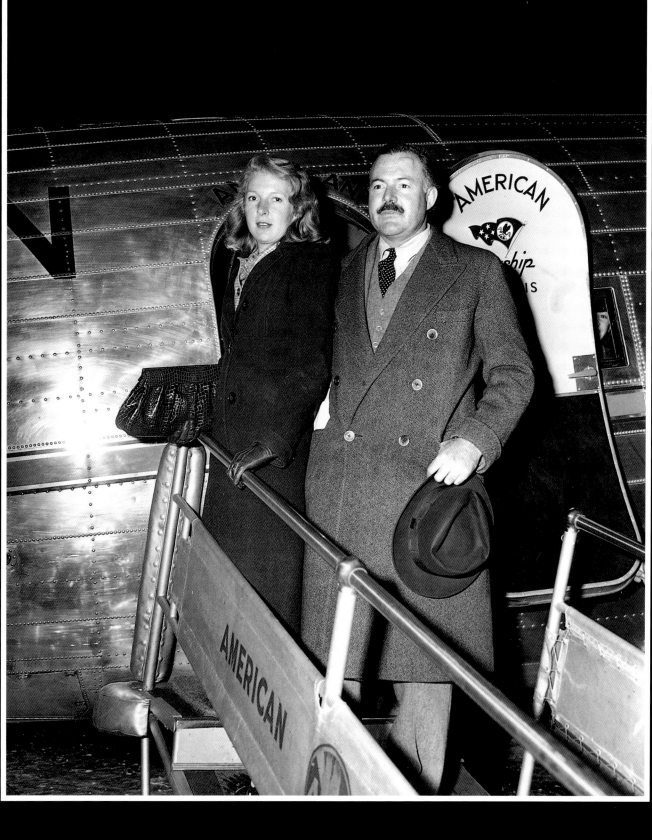

Ernest Hemingway and Martha Gellhorn. La Guardia Airport, New York, 1941.

Recently returned from the Spanish Civil War, author Hemingway visited New York with his wife.

TOP:
Brooklyn Dodgers.
Ebbets Field,
Brooklyn, 1941. Left
to right: Herman
Franks, Dolph
Camilli, Harold "Pee
Wee" Reese.

BOTTOM:
Brooklyn Dodgers.
Ebbets Field,
Brooklyn, 1941.
Left to right:
Cookie Lavagetto,
Reese, Billy Herman,
Camilli.

OPPOSITE:
Van Lingle Mungo.
Polo Grounds,
Manhattan, 1942.
Mungo, recently
traded to the New
York Giants, was
one of the hardest
throwers in
National League
history.

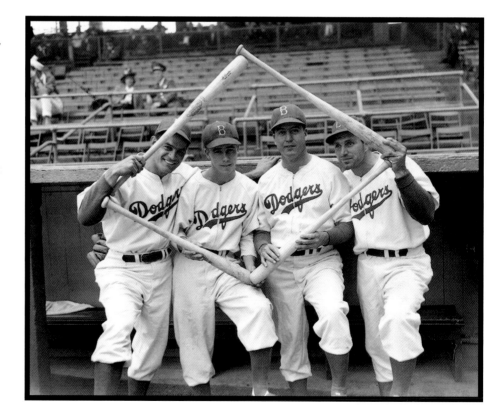

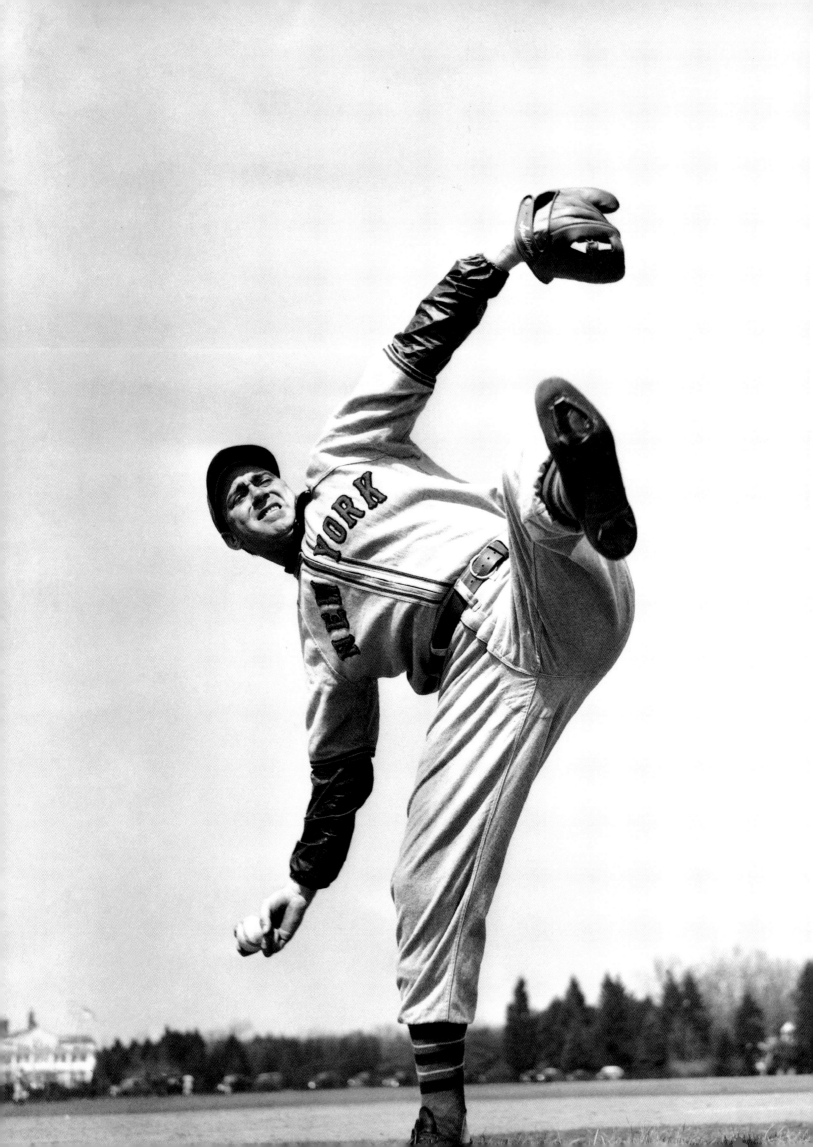

Boys with Toy Warplanes.
New York City, 1942.

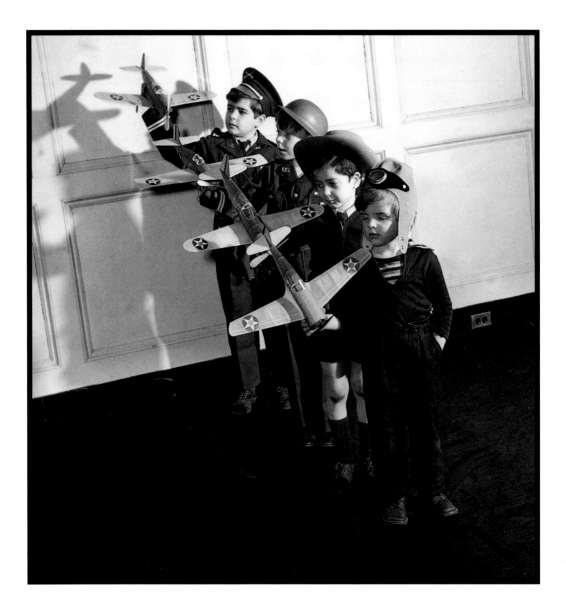

Bob Hope. New York City, 1942. Comedian, actor, and singer Hope began entertaining troops during World War II with the United Service Organizations (USO).

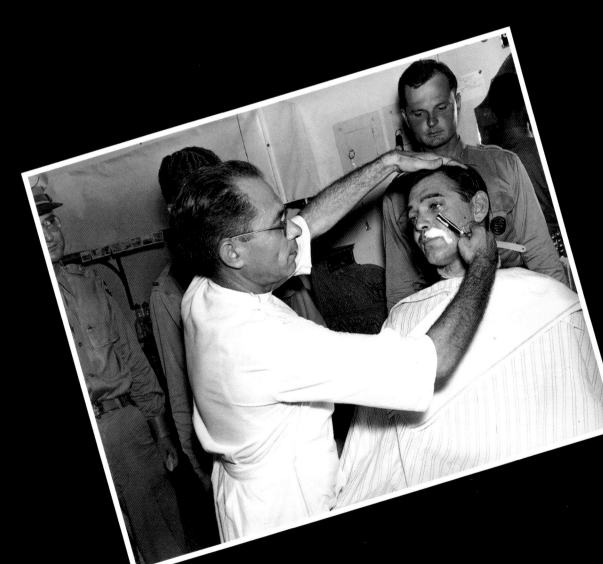

Clark Gable. New York City, 1942. Actor Gable, losing his trademark mustache with a military shave, had a distinguished World War II military career. He joined the Air Force after the death of his wife, actress Carole Lombard.

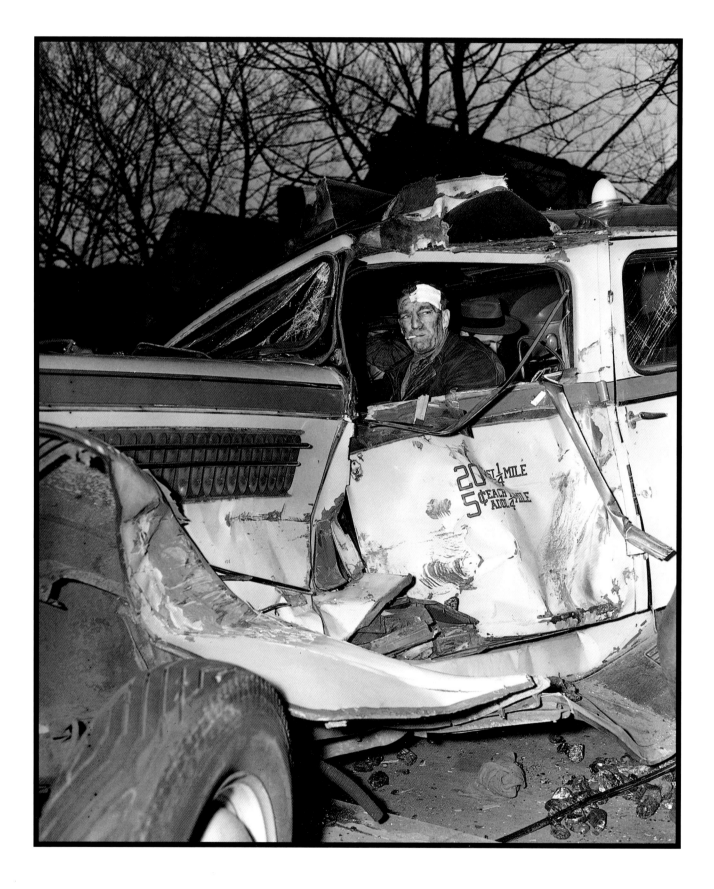

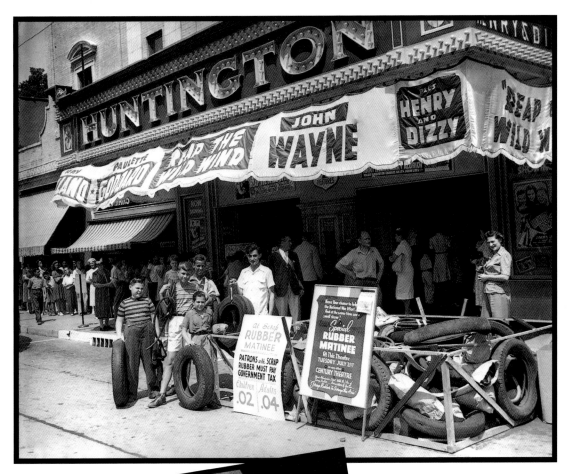

OPPOSITE:

Taxi Accident.
New York City,
1942.

ABOVE:

*Wartime Scrap
Rubber Collection.*
New York City, 1942.
During the war,
citizens held drives
for metal and
rubber, which were
melted down for
weaponry.

LEFT:

*Wartime Scrap
Metal Drive.* New
York City, 1942.

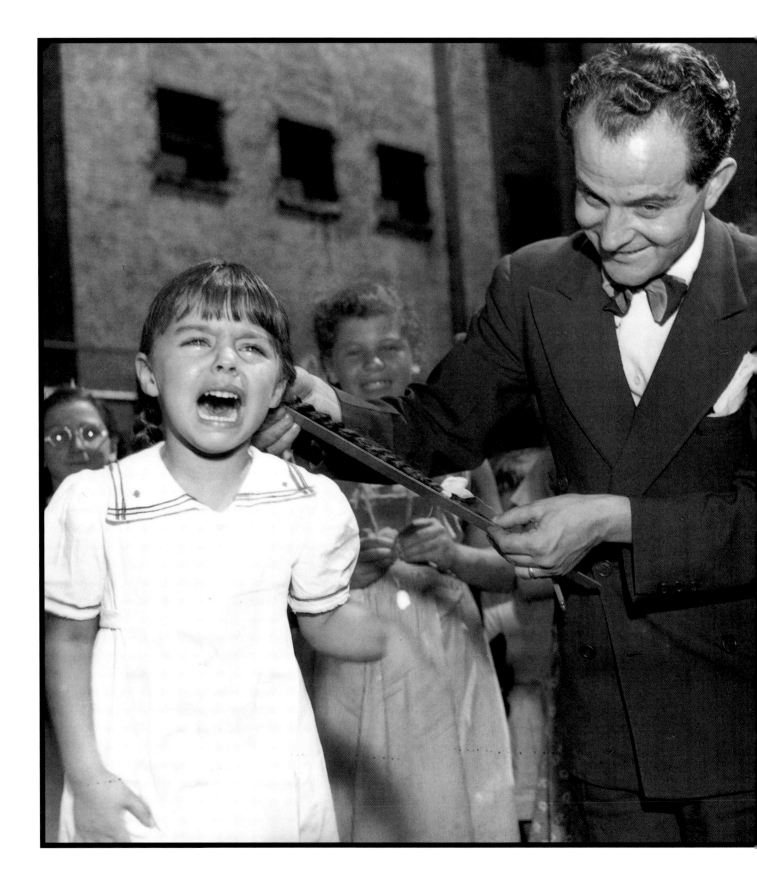

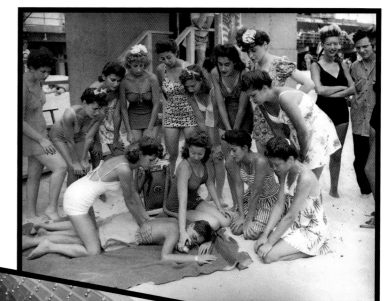

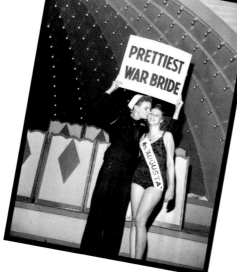

*Wartime Women
Lifeguards in Training.*
Long Beach, New
York, 1942. With so
many men overseas
and a critical need for
labor, women filled
jobs traditionally
restricted to men.
Women were hired in
such numbers that
their participation in
the job market sky-
rocketed.

FOLLOWING PAGES:
*Coffins with American
War Dead Return from
Europe to Brooklyn
Naval Yard.* 1944.

ABOVE:
Prettiest War Bride.
Atlantic City, 1943.
Many contests were
held as home-front
diversions during the
war, some sponsored
by the USO.

LEFT:
Pigtail Contest. New
York City, 1944.

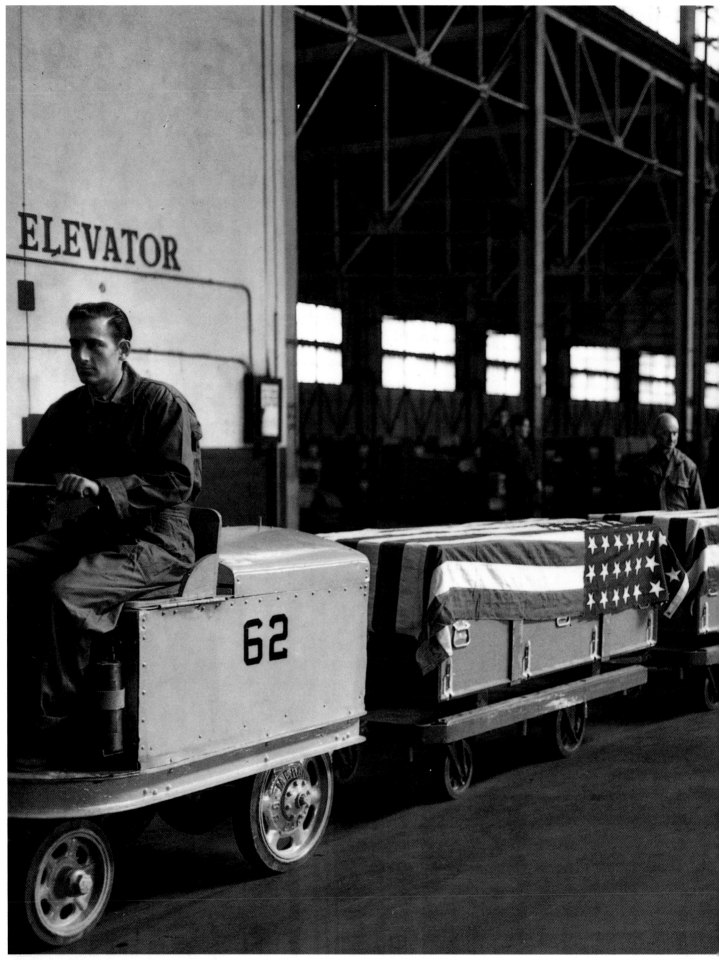

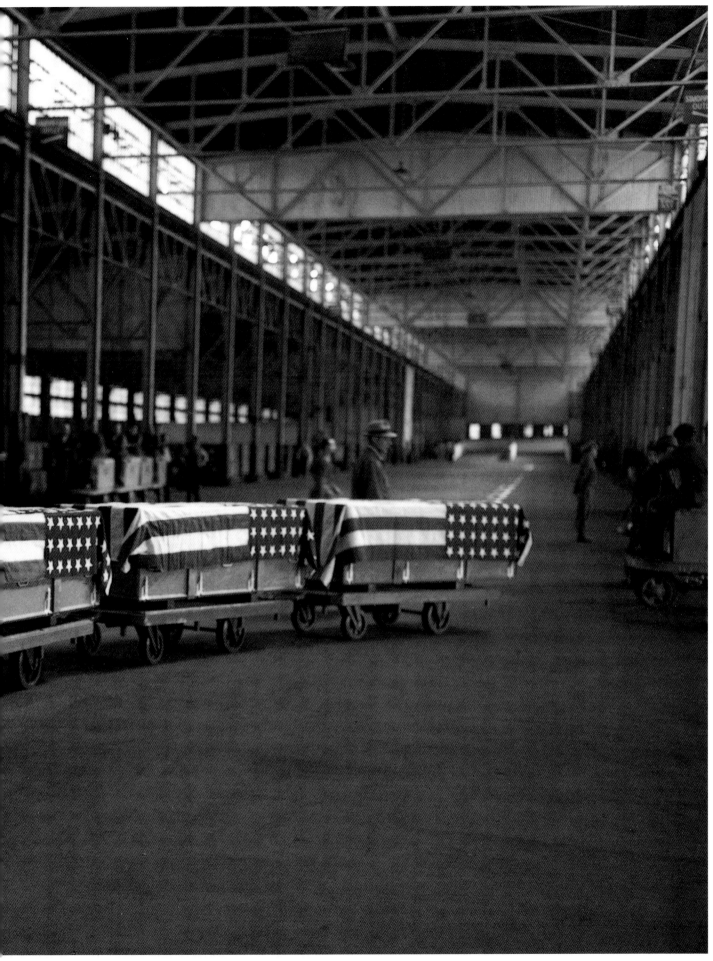

Wartime Hospital Facilities. Palm Beach, Florida, 1944. The Breakers, a glamorous resort that had been a location for many movies, was commandeered by the government during the war for use as a rehabilitation and medical facility. Doctors pioneered facial reconstruction techniques (below) while veterans convalesced (right) and able-bodied soldiers did calisthenics (bottom).

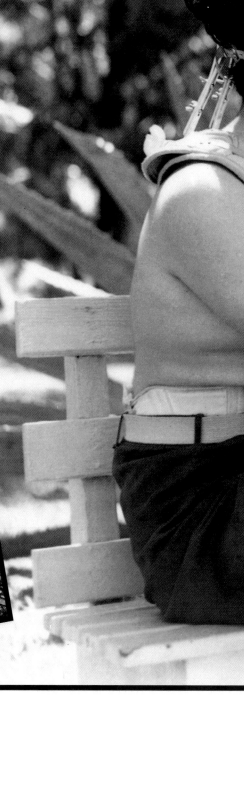

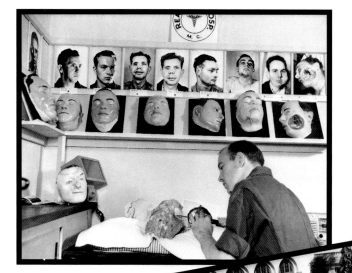

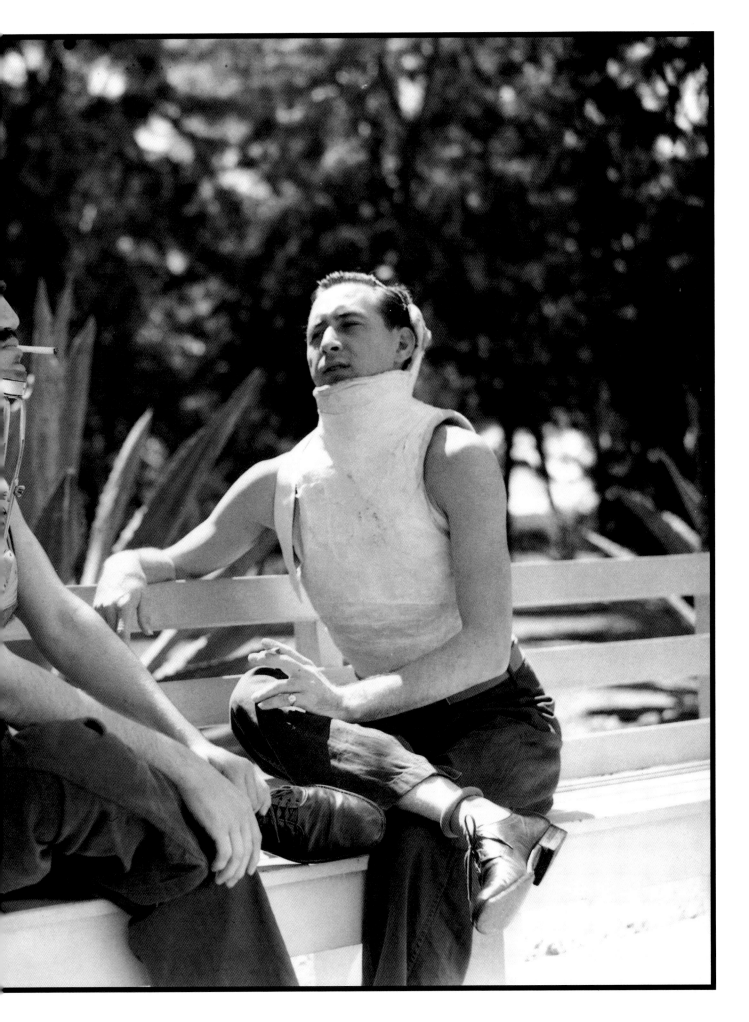

RIGHT:

Early Television
Variety Show.
Schenectady, New
York, 1944.

BELOW: *Frank*
Sinatra, Moss Hart,
and Ethel Merman.
New York City, 1944.
Singer and actor
Sinatra and playwright
Hart joined the "First
Lady of American
Musical Comedy" to
campaign for
Roosevelt's fourth run
for the presidency.

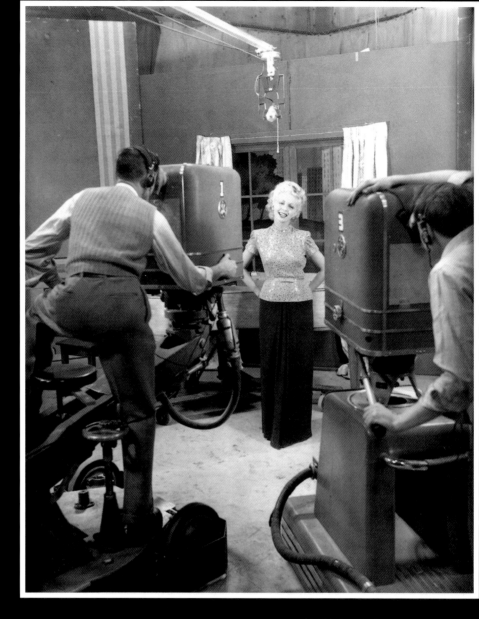

OPPOSITE: *Traffic on*
Brooklyn Bridge. 1944.

FOLLOWING PAGES:

Wartime Election
Night. New York City,
1944. Crowds awaited
election news in Times
Square; Roosevelt
would defeat New York
governor Thomas E.
Dewey.

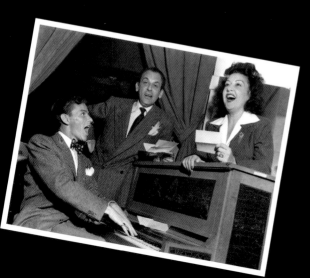

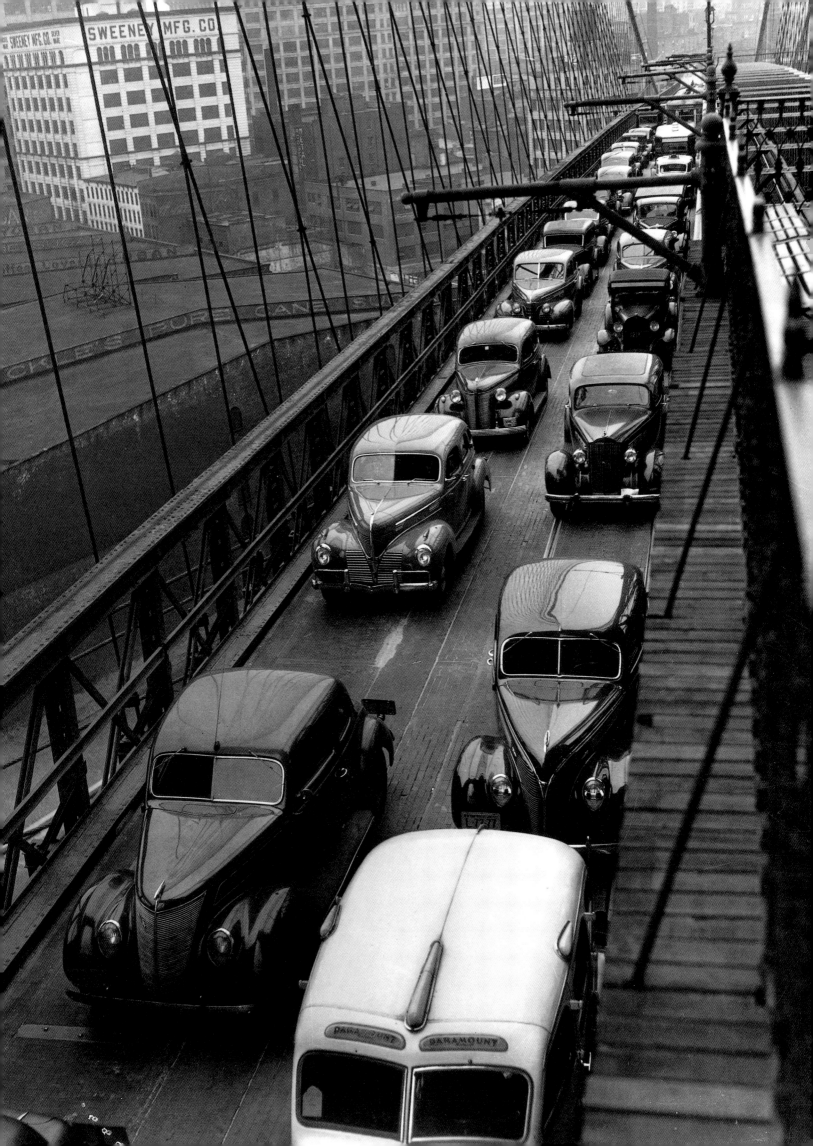

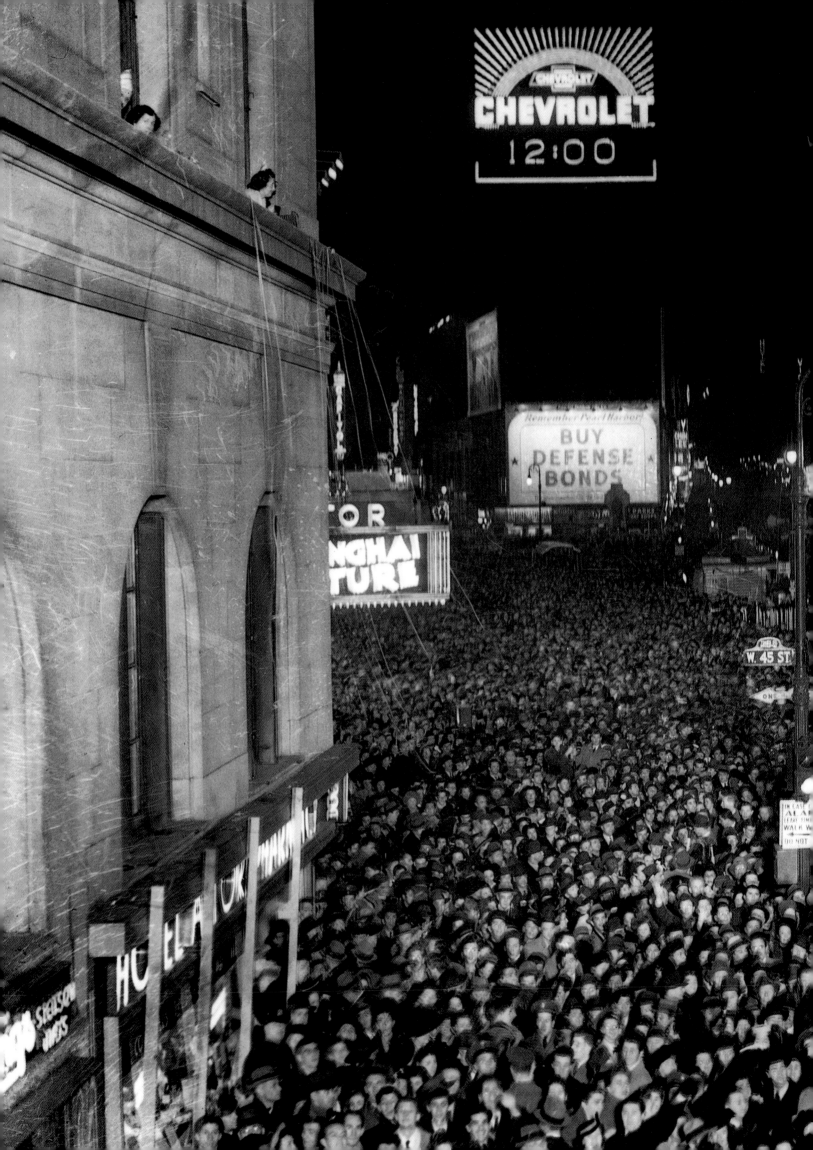

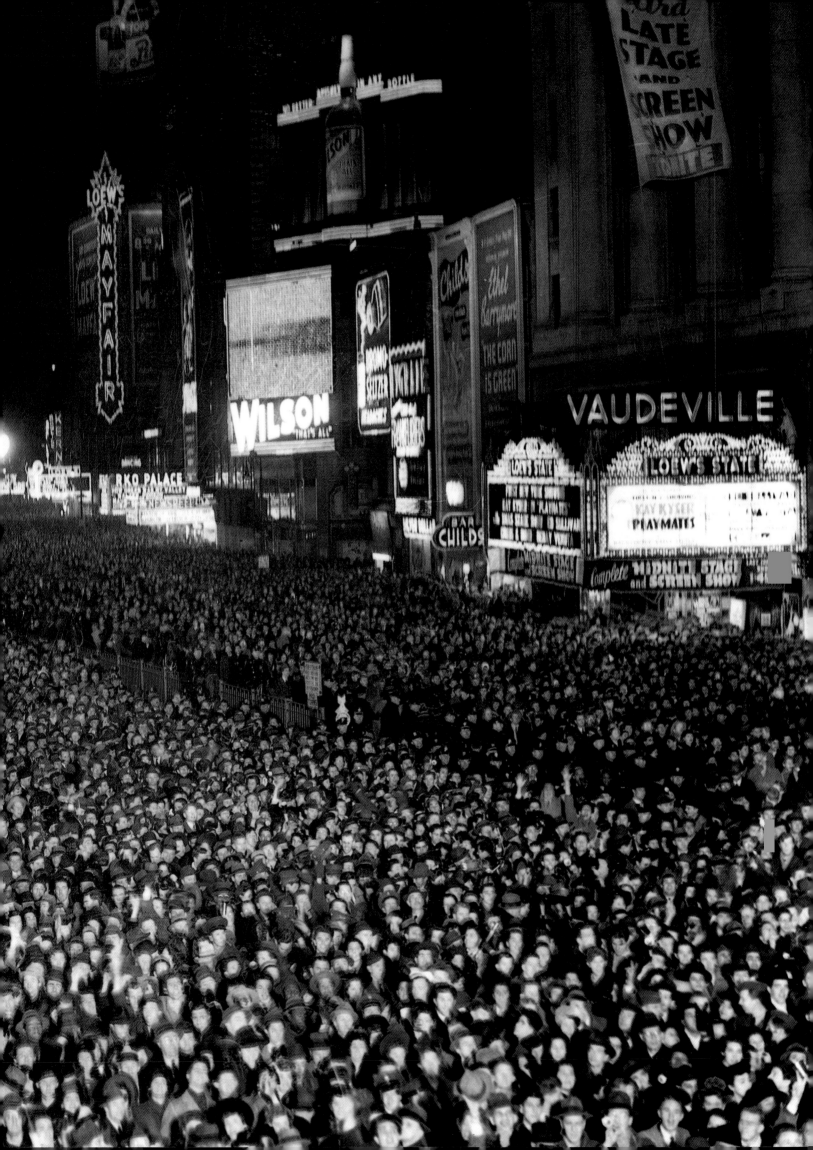

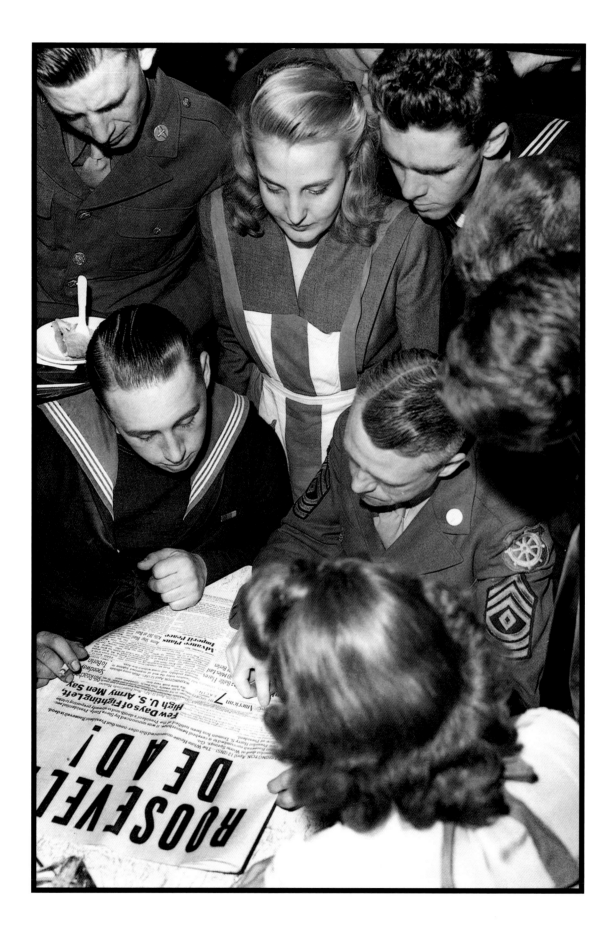

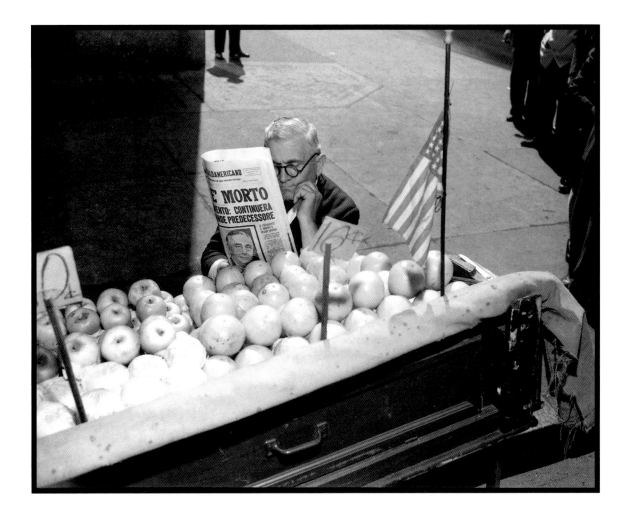

OPPOSITE AND ABOVE: *Roosevelt Dead.* New York City, 1945.

When President Roosevelt died unexpectedly of a cerebral hemorrhage on April 12, the country

mourned. Two hours later, Vice President Harry S. Truman was sworn in as president.

Less than one month after Roosevelt's death, the Germans would surrender unconditionally, bringing about

the beginning of the end of the war that he had worked so hard to win.

Leg Contest. New York City, 1945.

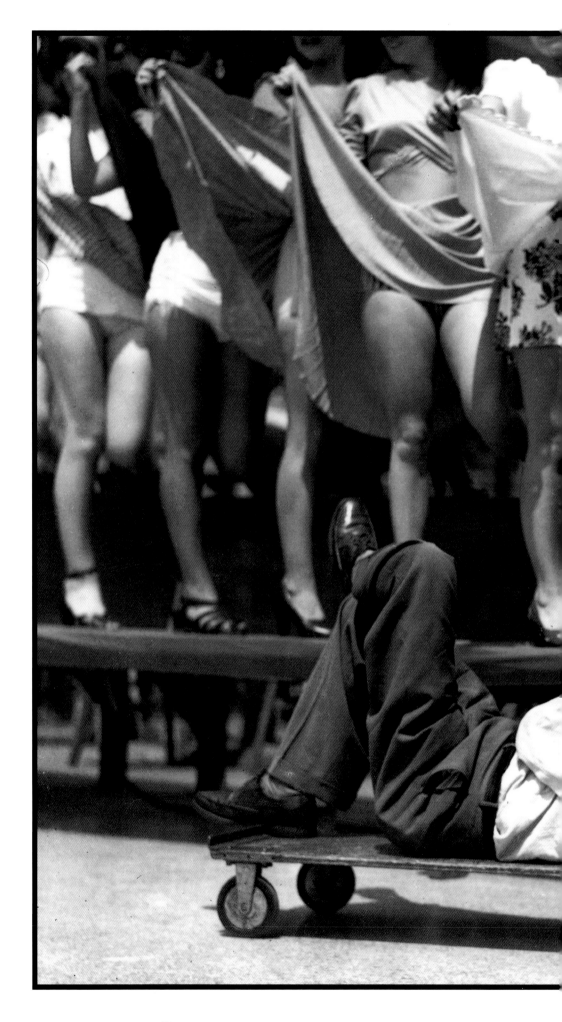

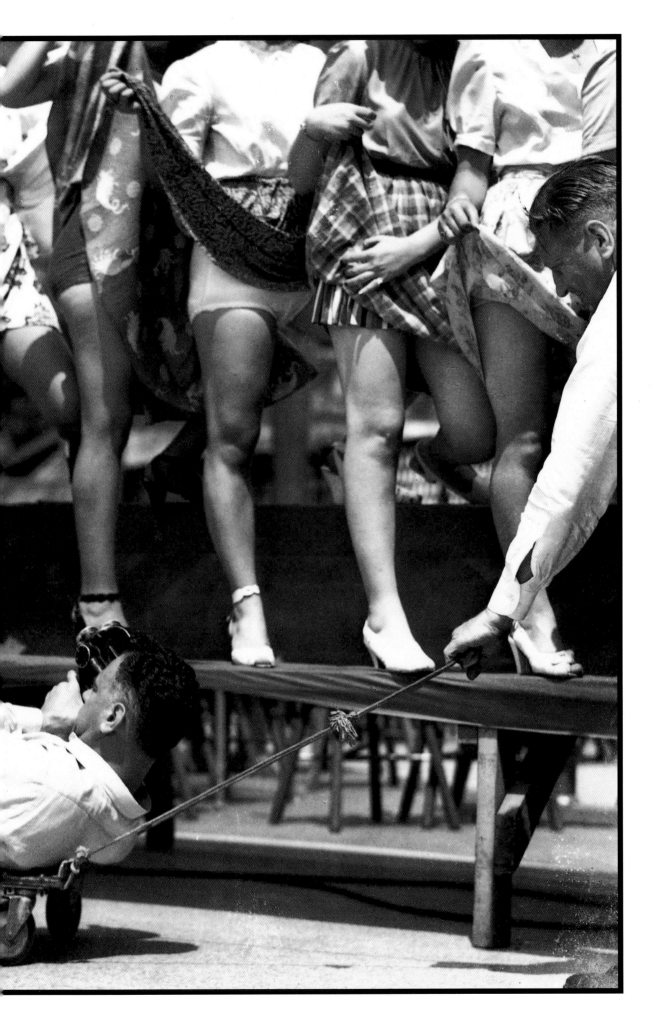

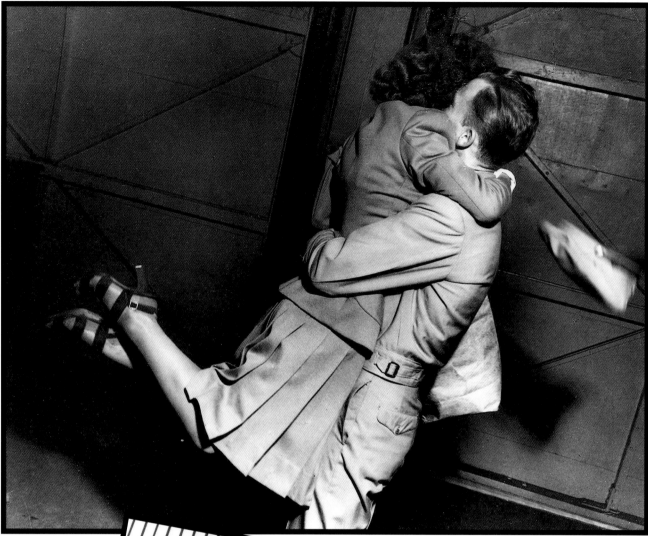

RIGHT: *Rita Hayworth.* New York City, 1945. Actress Hayworth was the ultimate World War II pinup girl; her picture in *Life* magazine was in great demand by American servicemen overseas and adorned the atomic bomb that was detonated off the Bikini Islands.

ABOVE AND RIGHT: *V-E Day Celebration in Times Square.* New York City, 1945. When Germany accepted terms of unconditional surrender on May 7, the world claimed May 8 to celebrate V-E (Victory in Europe) Day.

Marlene Dietrich.
New York City, 1945.
Off-duty for this shot,
Haberman had gone
to the docks with a
friend whose son
was to return on the
Monticello. When
actress Dietrich
unexpectedly
appeared, blowing
kisses to welcome
the returning
American soldiers,
Haberman grabbed
his camera and
yelled, "Who wants
to lift up a great
pair of legs?"
Many sailors happily
obliged.

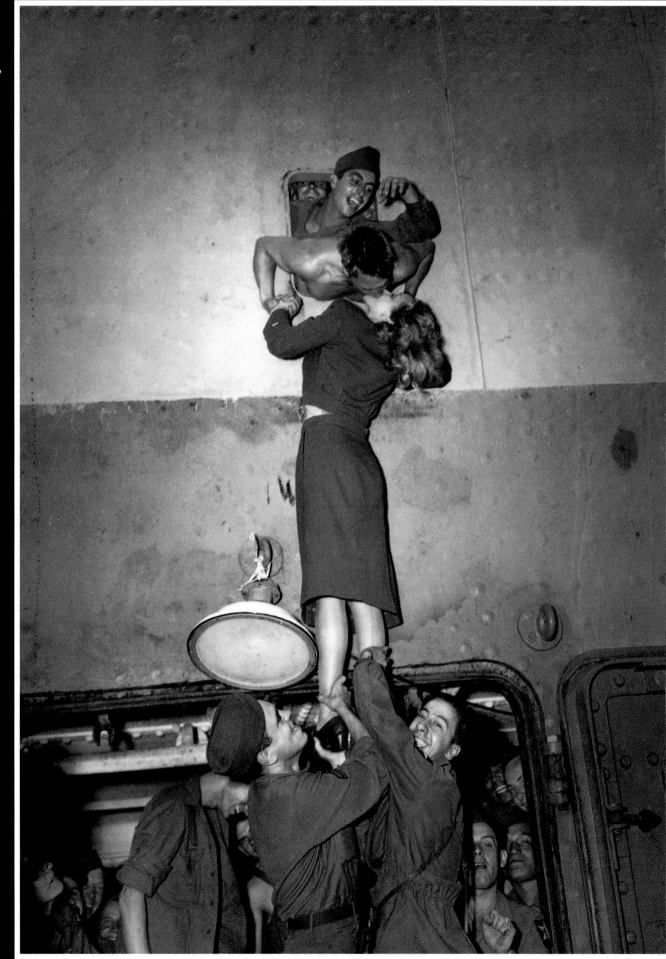

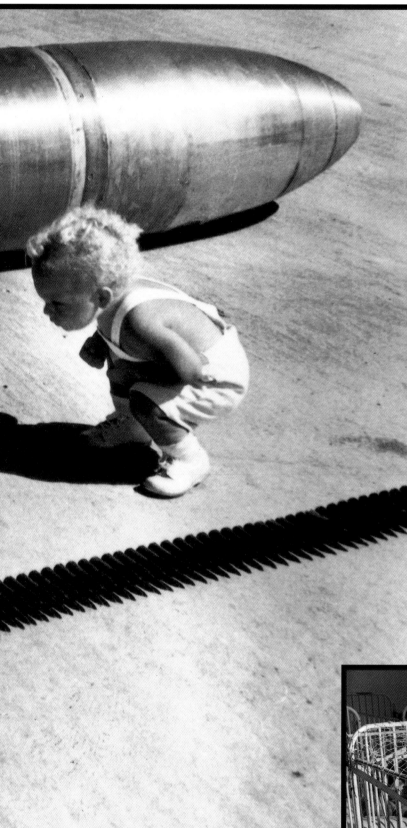

LEFT:

Child at Postwar Weapons and Ammunition Exhibition. New York City, 1946.

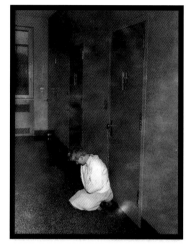

ABOVE AND BELOW:

Letchworth Village. Thiells, New York, 1946.

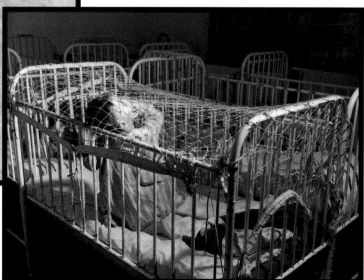

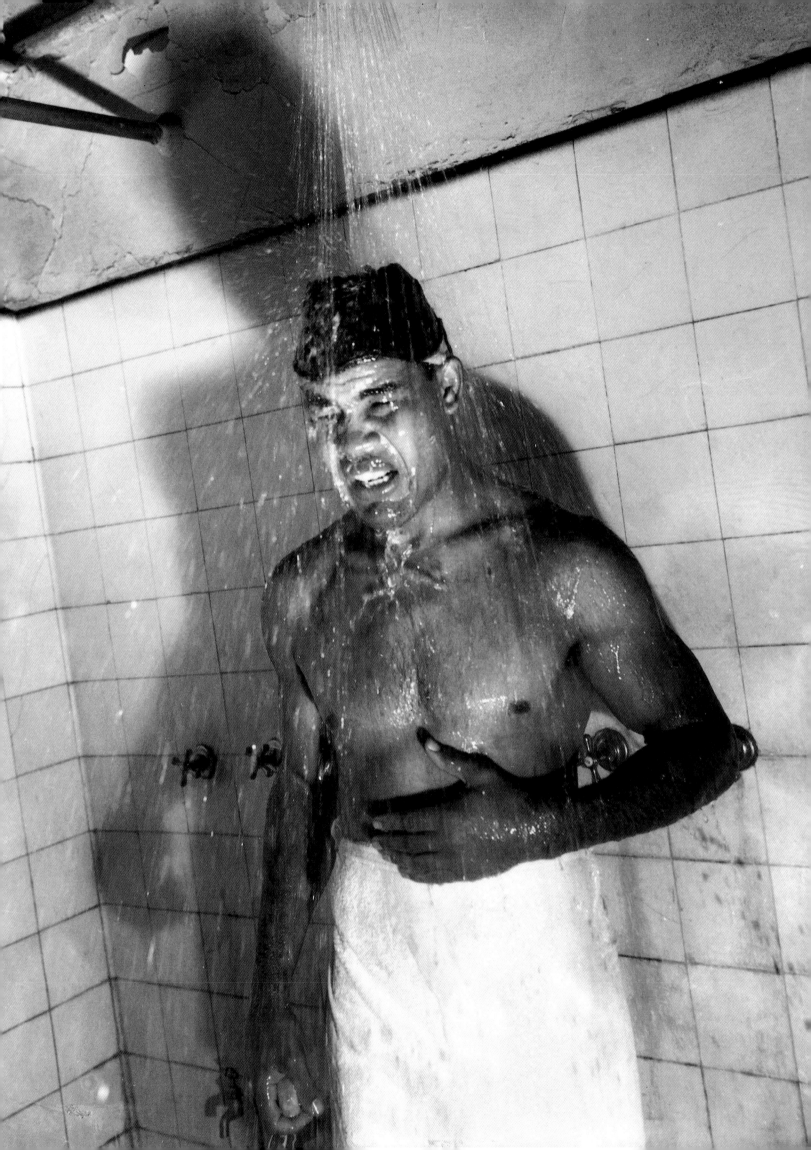

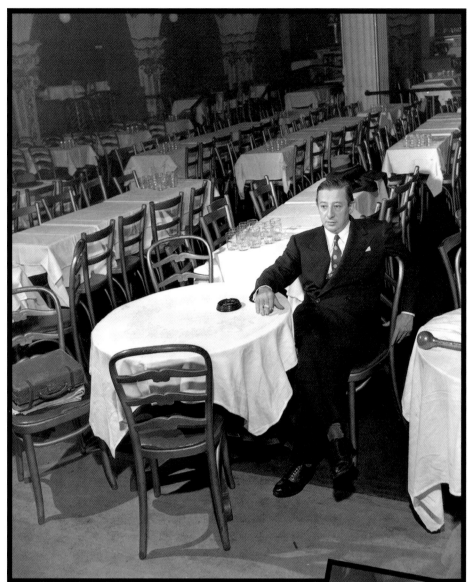

LEFT:
Billy Rose. New
York City, 1947.
Theatrical
impresario Rose
relaxed in his
Diamond
Horseshoe Club.

BELOW:
*Billy Rose's
Showgirls.*
New York City,
1947.

OPPOSITE:
Joe Louis. Yankee
Stadium, the Bronx,
1946. The "Brown
Bomber" cooled off
after defending his
world heavyweight
title against Tami
Mauriello.

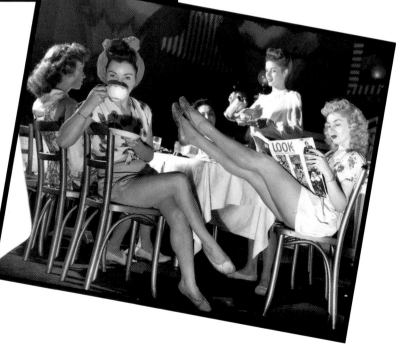

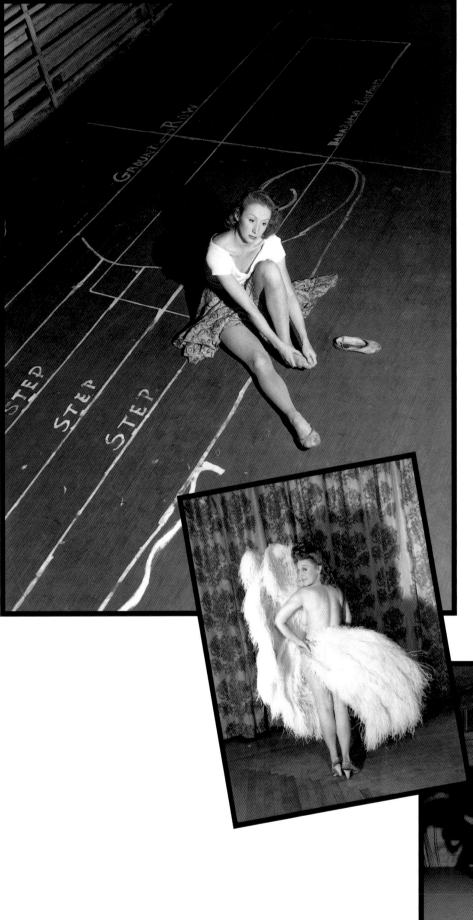

TOP:

Broadway Dancer.
New York City, 1947.

CENTER:

Sally Rand. New York
City, 1947. Rand was
reputed to be
America's greatest fan
dancer and stripper,
and continued to per-
form into the 1970s.

BOTTOM:

Ray Bolger. New York
City, 1947. Actor and
dancer Bolger, best
known as the
Scarecrow in *The
Wizard of Oz,*
rehearsed the
Broadway show
Charley's Aunt.

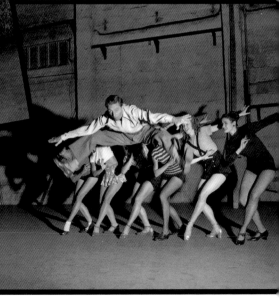

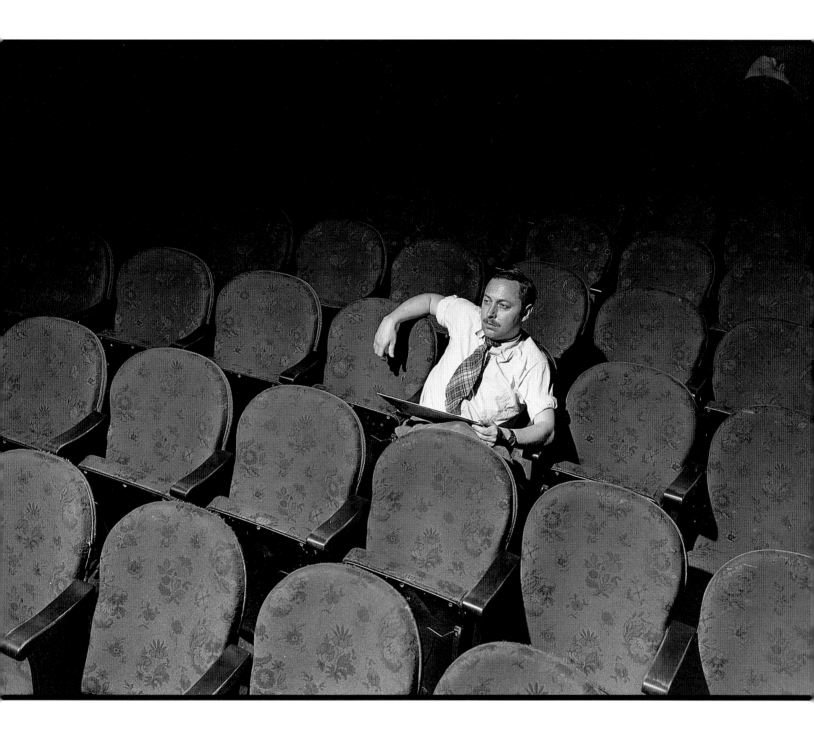

ABOVE:

Tennessee Williams.
New York City,
1947. Playwright
Williams presided
over the rehearsal
of his American
classic *A Streetcar
Named Desire,*
which would open
on December 3.

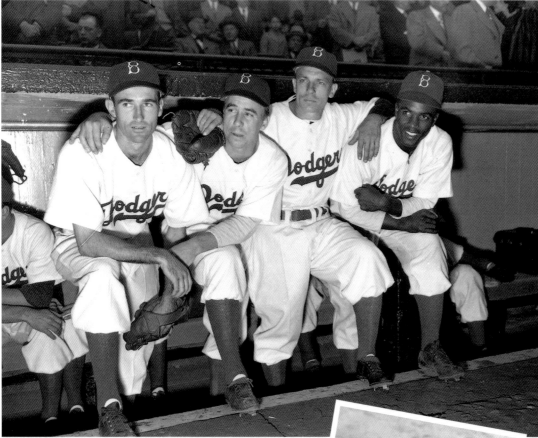

OPPOSITE:

Jackie Robinson.
Ebbets Field,
Brooklyn, 1947.
Recently hired by
the Dodgers,
Robinson, the
first black major-
league player,
waited to play on
opening day.
At the end of the
season, he won
baseball's first
Rookie of the Year
award.

ABOVE: *Brooklyn
Dodgers on Opening
Day.* Ebbets Field,
Brooklyn, 1947. Left to
right: John "Spider"
Jorgensen, Harold
"Pee Wee" Reese,
Eddie Stanky, Jackie
Robinson.

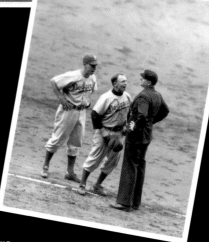

ABOVE:

Dodgers at World

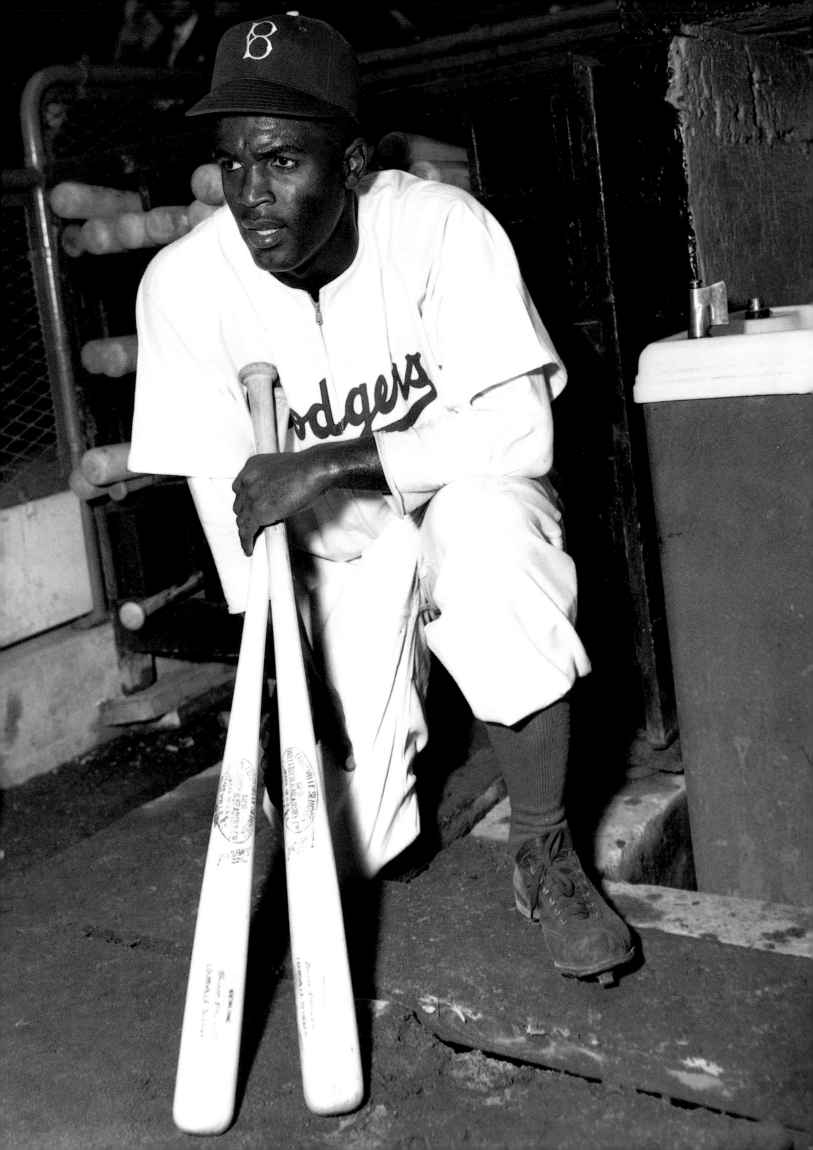

RIGHT:

Arthur Murray Dancers on Strike. New York City, 1947.

BELOW:

Beauty Operators on Strike. New York City, 1947.

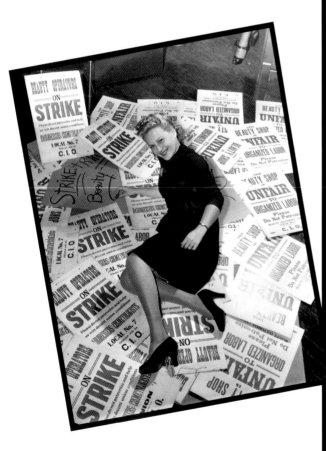

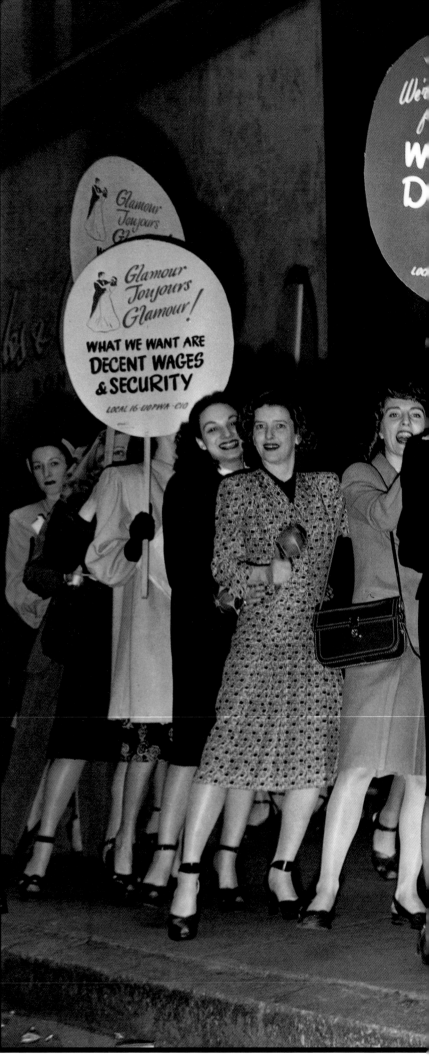

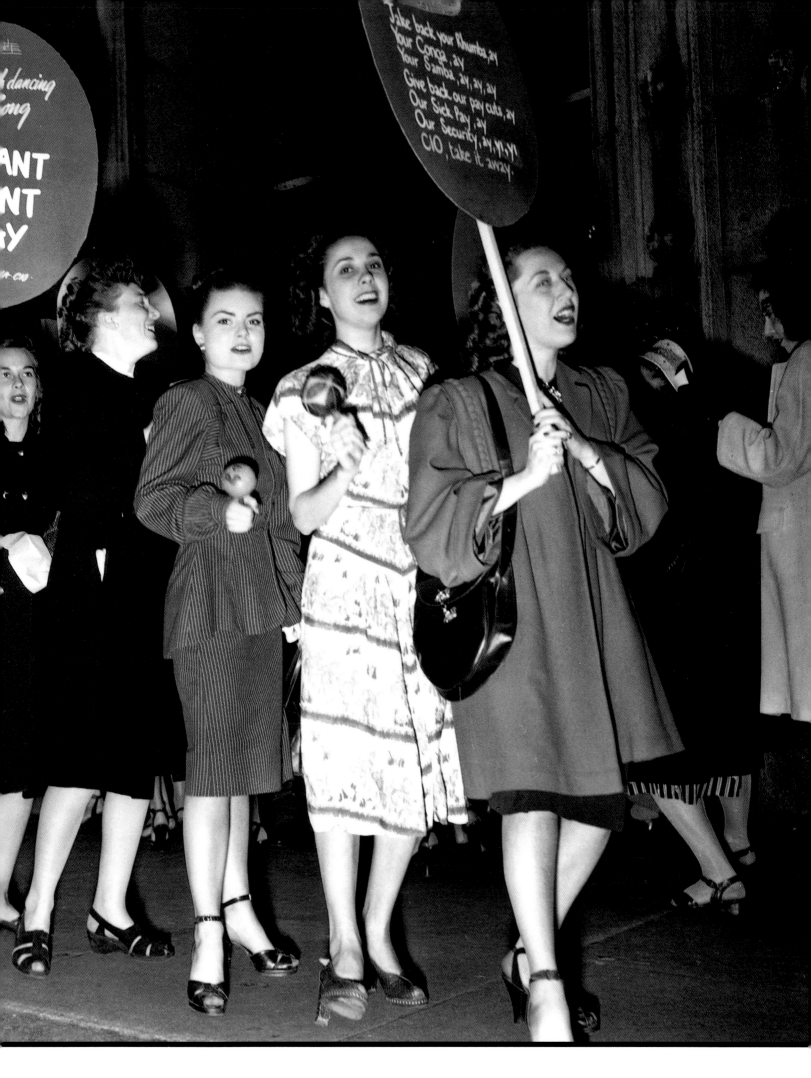

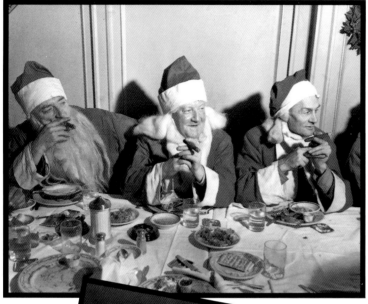

TOP:

*Santa Clauses
Get Ready.* New
York City, 1947.

CENTER:

*American Legion
Parade.* New York
City, 1947.

RIGHT:

*"Learn to Be
Americans"
Camp for
Immigrants.*
New York, 1947.

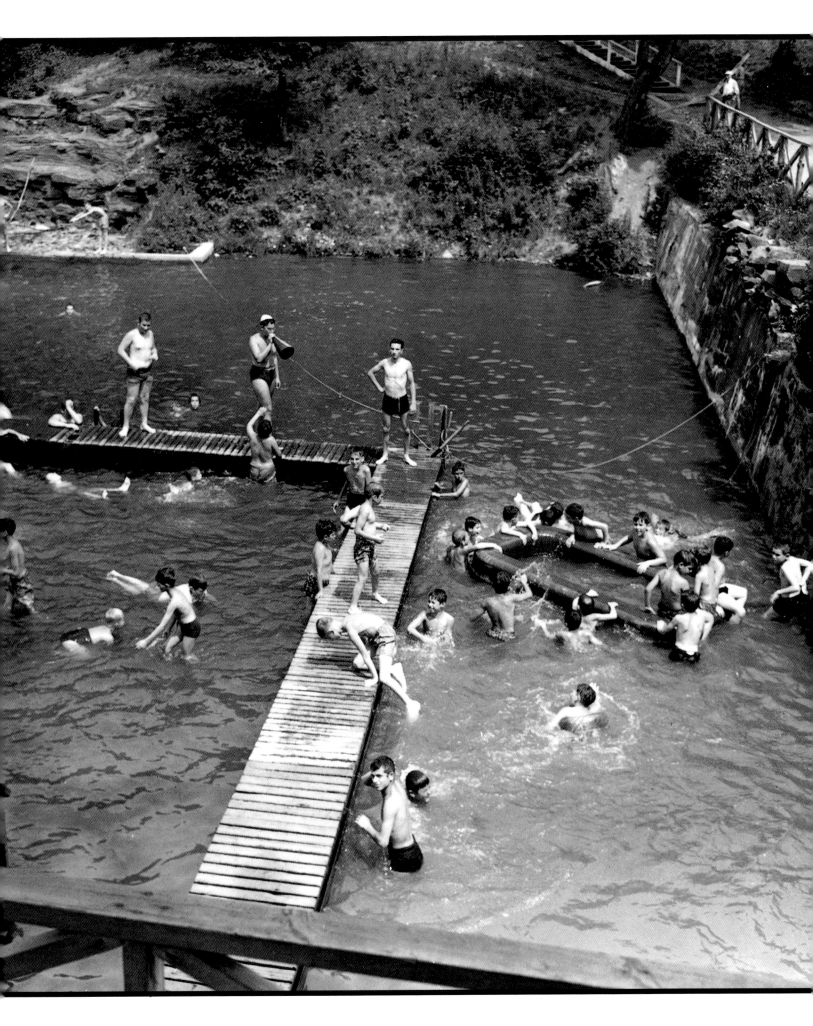

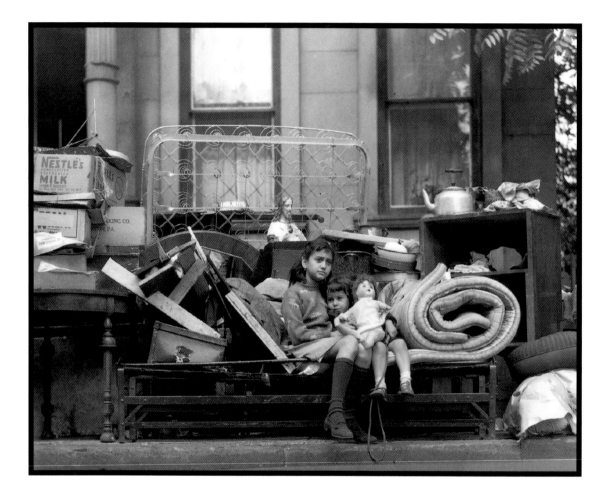

Álvarez Family Eviction. New York City, 1947.

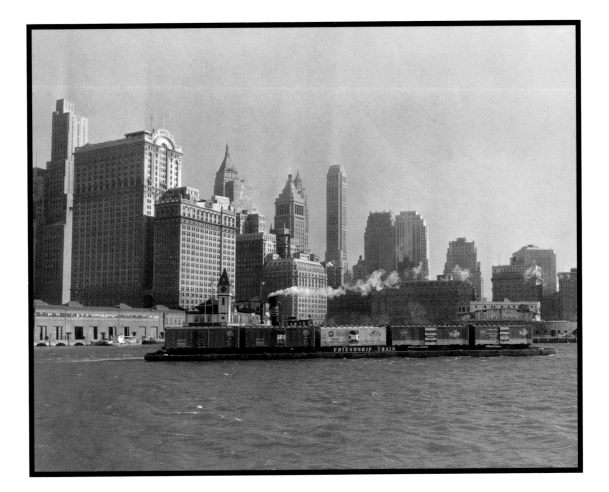

Friendship Train Carrying Food to Europe. New York City, 1947.

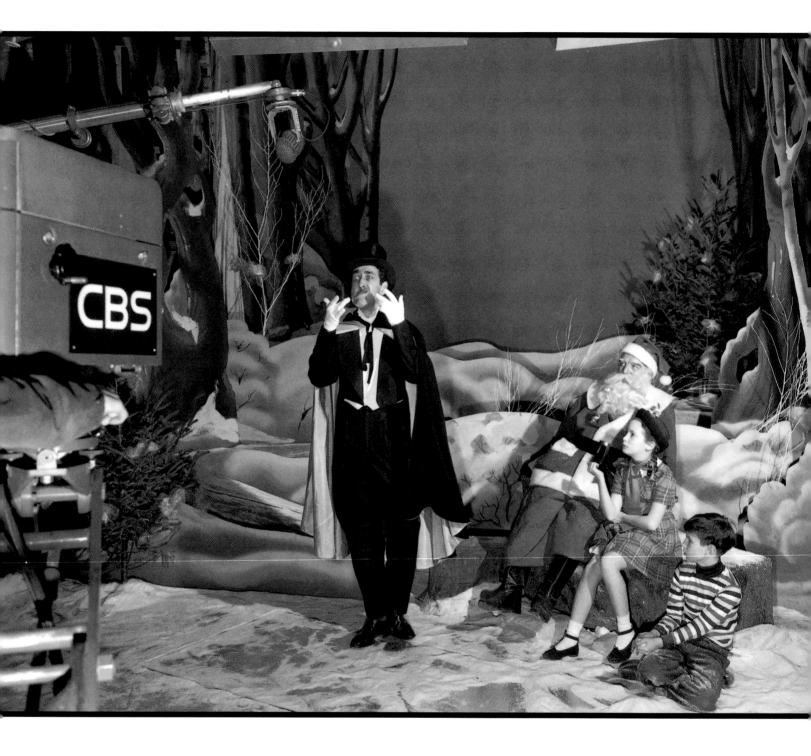

Early Television Christmas Special. New York City, 1948.

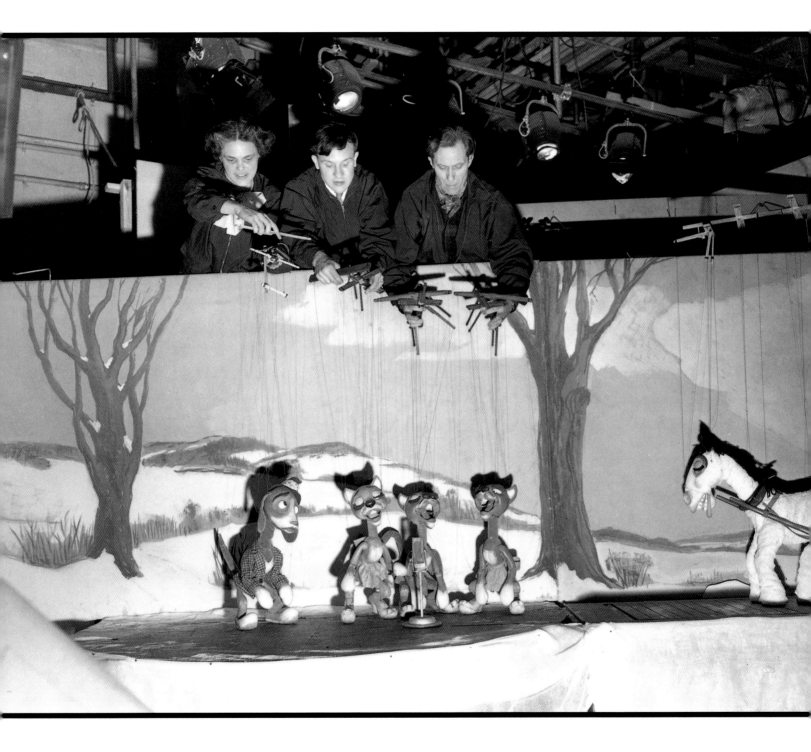

Early Television Puppet Show. New York City, 1948.

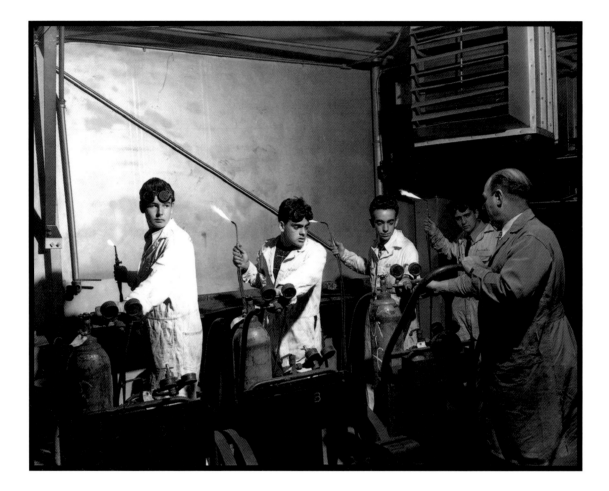

ABOVE:

Aviation Trade
School. Brooklyn,
1948.

OPPOSITE:

Needle Trade
School. Brooklyn,
1948.

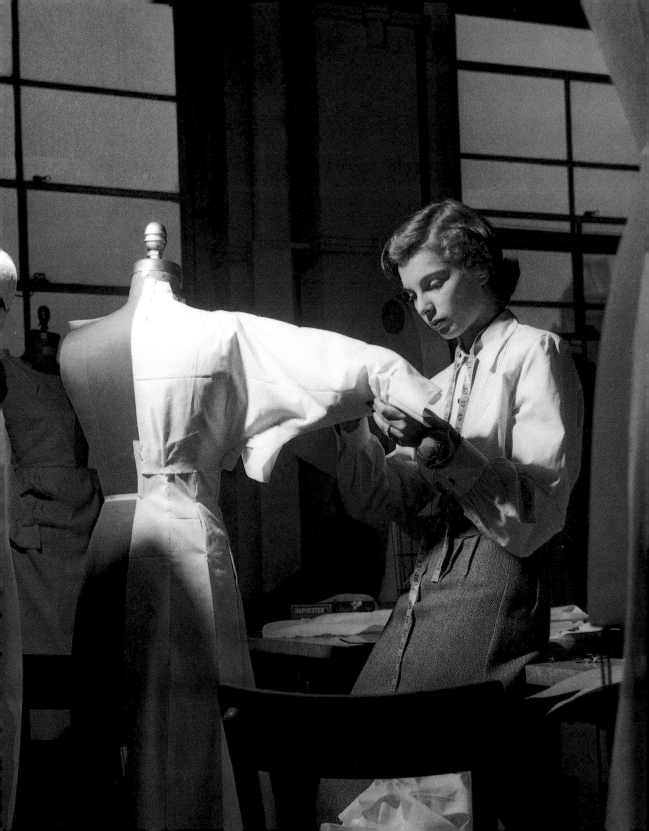

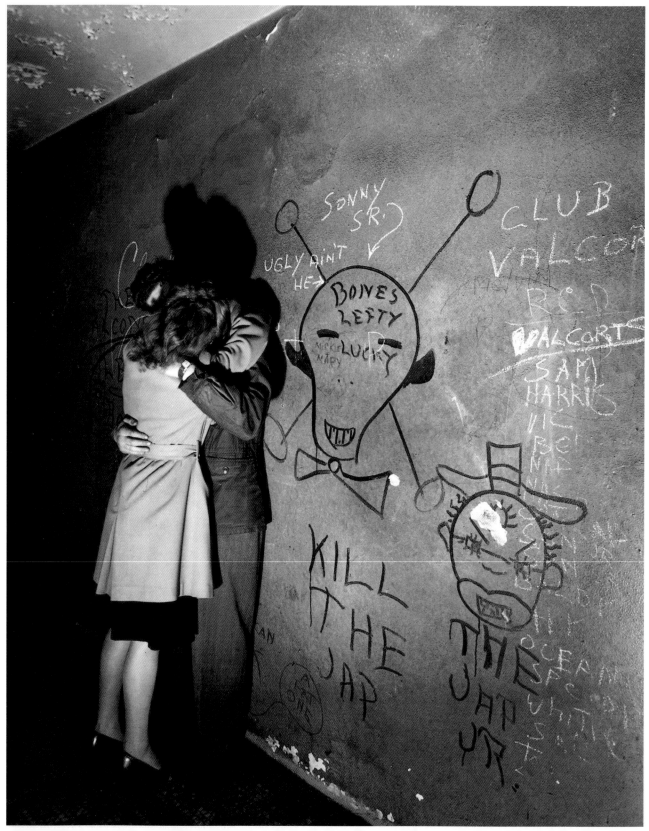

OPPOSITE:
Neighborhood Kiss.
The Bronx, 1948.

TOP:
Annual Children's
Sidewalk Art Show.
The Bronx, 1948.

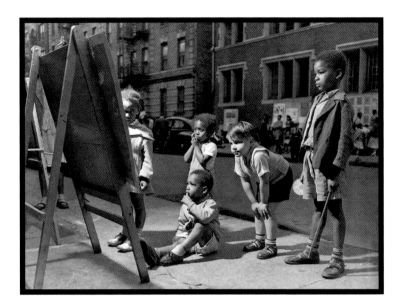

BOTTOM:
Poultry Store.
Brooklyn, 1948.

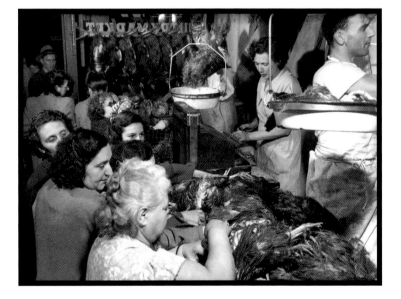

RIGHT:

New York City

Summer. 1948.

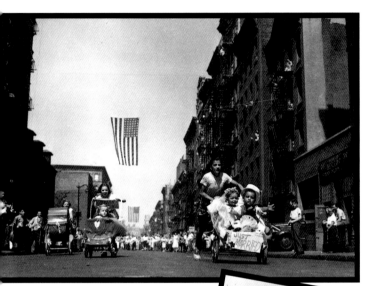

ABOVE AND
RIGHT:
*Anything Wheels
Race.* New York
City, 1948.

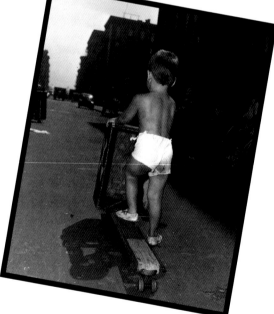

114

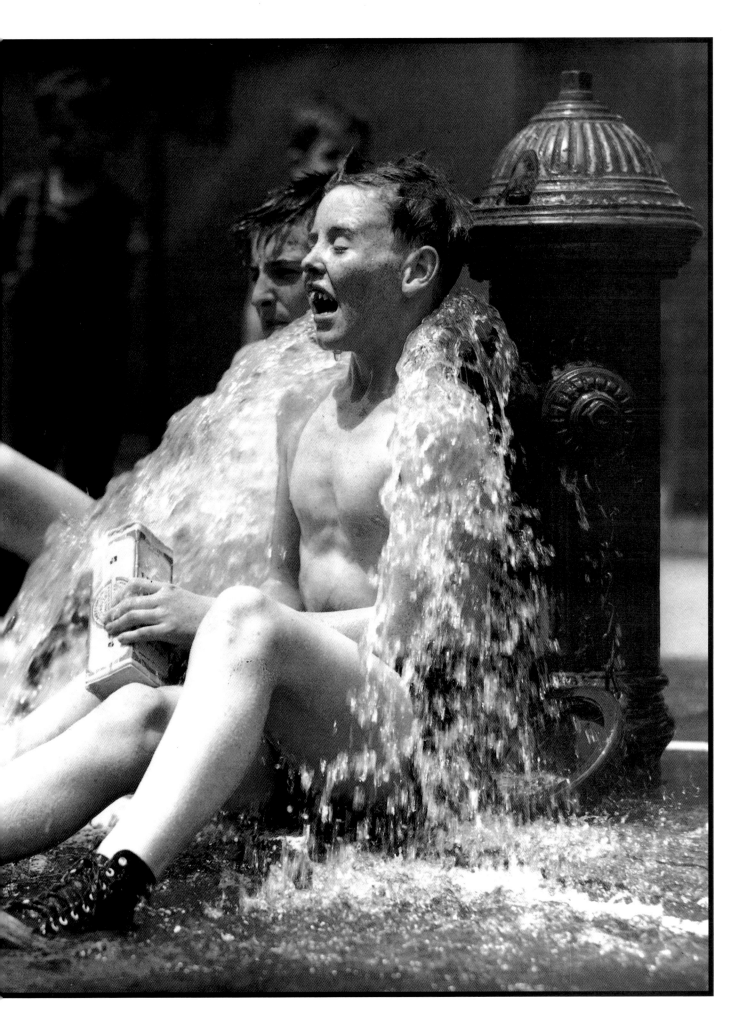

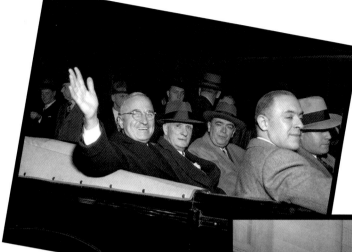

BELOW AND
BOTTOM:
*Democratic National
Convention.*
Philadelphia, 1948.

ABOVE:

Harry S. Truman.
New York City, 1948.
President Truman,
here campaigning for
his second term, had
stirred much contro-
versy with his strong
civil rights plank.
Republican candidate
Thomas E. Dewey, who
had been defeated by
Roosevelt in 1944,
was so heavily favored
that the *Chicago Daily
Tribune* announced
"Dewey Defeats
Truman" on its front
page before learning
that Truman had won
an upset victory.

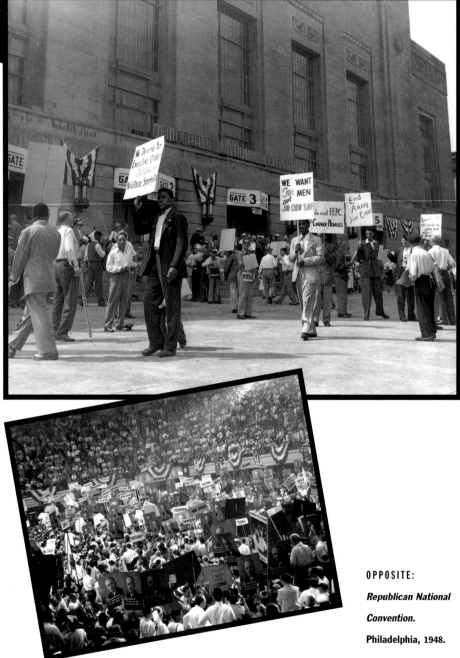

OPPOSITE:
*Republican National
Convention.*
Philadelphia, 1948.

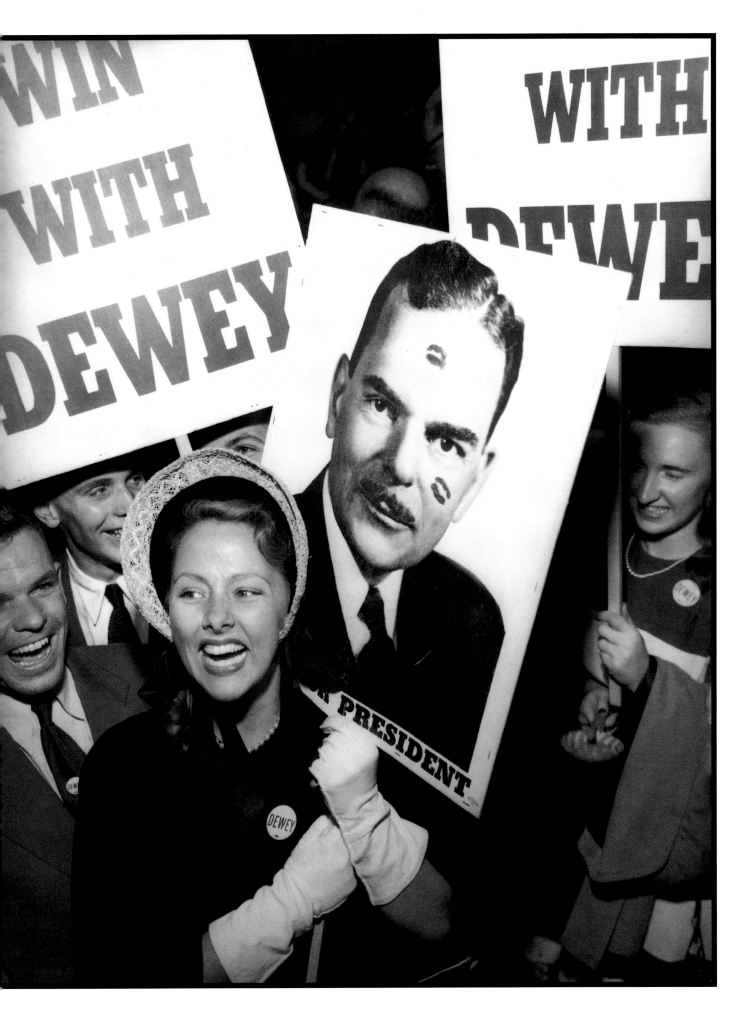

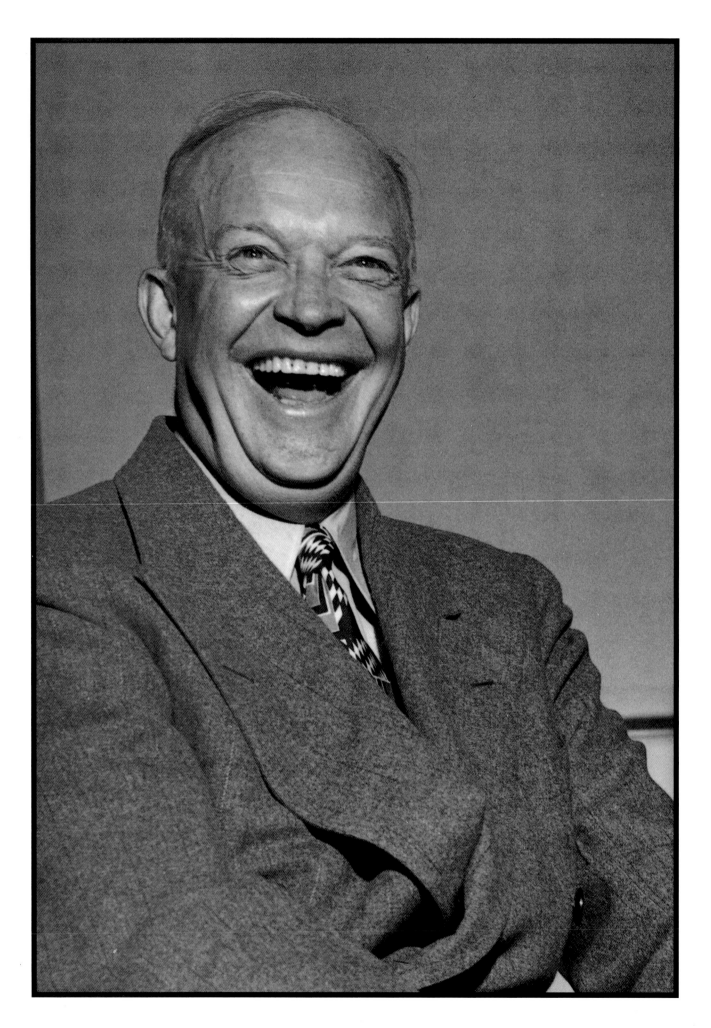

OPPOSITE:

Dwight D. Eisenhower.
Columbia University,
Manhattan, 1948.
World War II hero
and future president
Eisenhower had just
resigned his post as
chief of staff of the
U.S. army to head
Columbia University.

ABOVE:

Rocky Graziano. Ellenville,
New York, 1949. Former
middleweight champion
Graziano trained
at the Nevele Resort
Hotel.

BELOW: *Alger Hiss.* New York City, 1949. Hiss, second from right, took the subway home after a day of
hearings. Hiss was accused of obtaining secret documents for the Soviets while working for
the State Department in the 1930s. Because the statute of limitations for espionage had expired,
Hiss could only be indicted and convicted for perjury.

OPPOSITE: *Richard Nixon.* New York City, 1949. As a member of the House Un-American Activities Committee
(HUAC), Congressman Nixon, here at Hiss's trial, burst into the national spotlight with his investigation into
the Whittaker Chambers–Alger Hiss case. The sensationalized hearings fueled national anticommunist feeling,
paving the way for Senator Joseph McCarthy and the Red Scare of the 1950s.

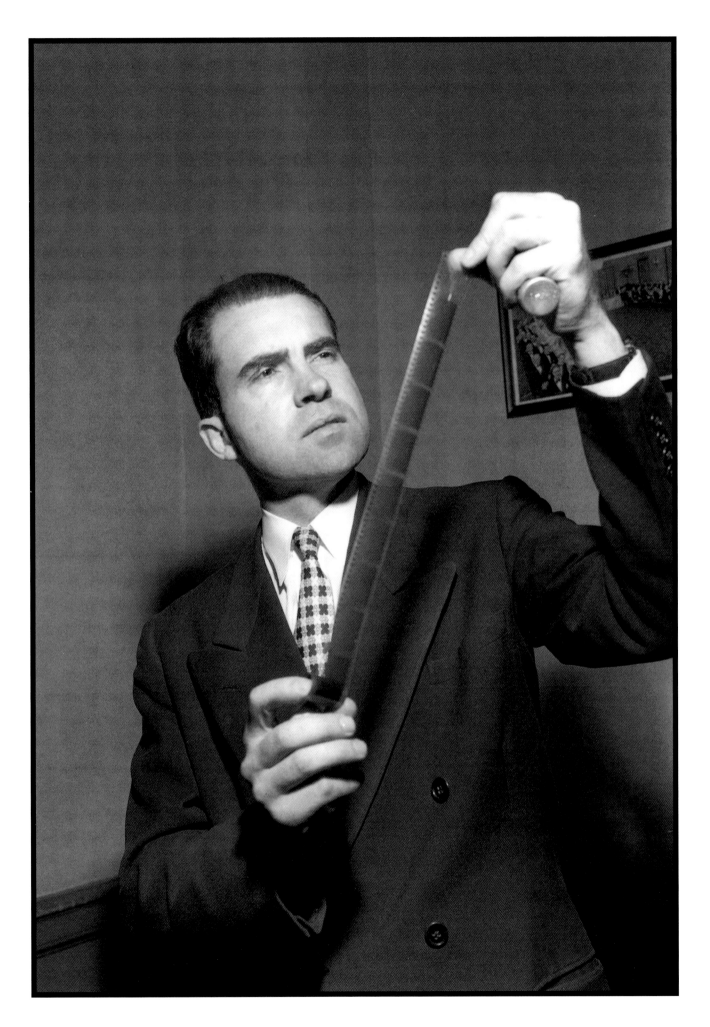

ABOVE:

Jack Benny and Fred Allen. New York City, 1944. Radio hosts Benny and Allen put their long-standing mock feud to rest at the Stork Club.

ABOVE:

Last Day of Publication at the New York Star. New York City, 1949. Haberman had worked for *PM* throughout the 1940s. In June 1948 *PM* was sold and became the *New York Star;* when the *Star* folded in January 1949, Haberman went to work for CBS.

RIGHT:

Levittown.
Hempstead, New
York, 1949. Created
by William Levitt
amid the postwar
housing shortage,
Levittowns revolu-
tionized the housing
industry with their
inexpensive, identi-
cal, mass-produced
homes. Twenty miles
outside Manhattan,
the original
Levittown (right),
was the first modern
suburb.

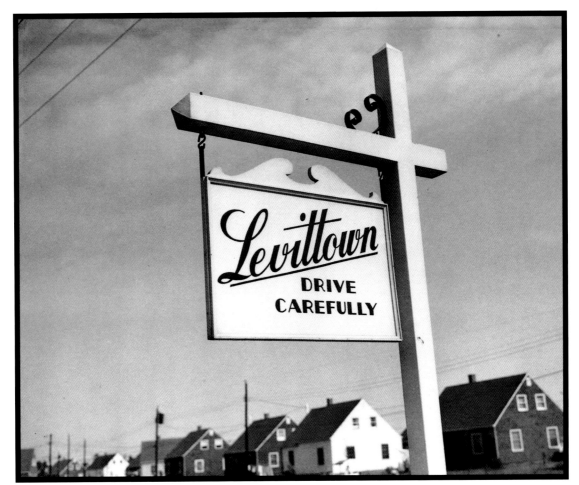

50s

1950	
JAN 21	Alger Hiss convicted of perjury
JUN 25	North Korea invades South Korea
NOV 19	American Red Cross stops tagging blood with donor's race
1951	
JAN 27	Atomic bomb tested in Nevada desert
APR 5	Rosenbergs receive death penalty for espionage
AUG 14	William Randolph Hearst dies
1952	
JUN 15	*Anne Frank: Diary of a Young Girl* published in U.S.
SEP 20	*The Jackie Gleason Show* debuts
NOV 4	Eisenhower and Nixon elected in landslide
1953	
MAR 5	Joseph Stalin dies
OCT 5	Yankees win fifth consecutive World Series
DEC 18	FCC rules color TV can go on the air
1954	
FEB 25	Army-McCarthy hearings begin
MAY 17	Supreme Court's *Brown* decision outlaws public-school segregation
DEC 31	U.S. records more than 4 million births in one year
1955	
JUL 17	Disneyland opens in Anaheim, CA
OCT 4	Brooklyn Dodgers win their first World Series
DEC 1	Rosa Parks arrested for refusing to cede bus seat
1956	
AUG 2	First bank drive-up window opens
SEP 9	Elvis Presley appears on *The Ed Sullivan Show*
NOV 6	Eisenhower defeats Adlai Stevenson for second time
1957	
MAY 2	Joseph McCarthy dies
SEP 25	Federal troops enforce integration of Little Rock high school
OCT 4	*Sputnik* launched by Soviets
1958	
MAR 27	Khrushchev assumes leadership of Soviet Union
JUL 29	NASA established to conduct nonmilitary space activities
DEC 10	Albert Camus receives Nobel prize for literature
1959	
JAN 1	Fidel Castro overthrows Batista in Cuba
AUG 21	Hawaii becomes 50th state
OCT 2	*The Twilight Zone* debuts

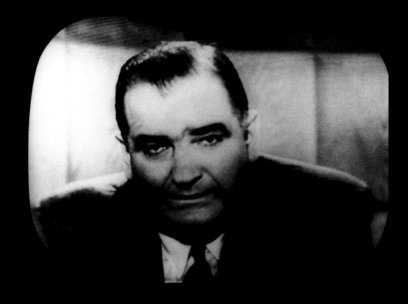

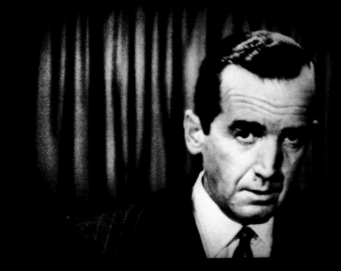

Edward R. Murrow and Joseph McCarthy. New York City, 1954. With the approval of CBS,
Murrow (bottom) was the first journalist to launch a full-scale attack on Senator McCarthy for his
anticommunist campaigns. Murrow's brave stand on this *See It Now* program is thought
to have contributed to McCarthy's political demise.

THE 1950s Having saved the world from Nazis and Fascists, we now faced what many believed to be a more terrorizing threat—communism. "Reds," we were told, existed not only in Russia and China but in our own cities and towns, schools and neighborhoods. Men like Senator Joseph McCarthy and a young congressman named Richard Nixon were eager to feed these fears to build their own power base. They were helped by the pounding-fist diplomacy of Soviet premier Nikita Khrushchev, who threatened us even as he walked through our fields and streets.

No one can terrorize a whole nation, unless we are all his accomplices. McCarthy didn't create

Despite the paranoia, America prospered and the work force began its transformation from industrial to service economy. Much of this was fueled by the increase in higher education caused by an overload of returning soldiers and a generous GI Bill. One of those soldiers would become president. People liked Ike, and the winning General Dwight D. Eisenhower, with Nixon at his side, succeeded Harry S. Truman.

this situation of fear. He merely exploited it, and rather successfully. —Edward R. Murrow, 1954

The reporting of the news gained a greater immediacy with the advent of television, and the entertainment world entered our home with dynamic impact. It was as if a dam had given way. We laughed with Jackie Gleason and *The Honeymooners* and moved to the rhythms of Dizzy Gillespie and Louis Armstrong. Newsmen like Edward R. Murrow would take us to places we had never been. Marilyn Monroe and Elizabeth Taylor made our hearts beat faster and we could see firsthand why Willie Mays was amazing, why Mickey Mantle was every boy's hero. Alfred Hitchcock brought his macabre sense of humor and mystery to the small screen, all from the comfort of our living rooms. —Walter Cronkite

*Frank Sinatra and
Ava Gardner.*
Philadelphia, 1951.
As a personal favor
to singer and actor
Sinatra, Haberman
cut short his vaca-
tion to be the only
professional photog-
rapher at Sinatra's
high-profile wedding
to actress Gardner;
Haberman's pho-
tographs were dis-
tributed throughout
the country.

ABOVE:

Grace Kelly. New
York City, 1950.
Actress Kelly had
recently moved to
New York when
she was hired for
a bit part in a
Studio One pro-
duction. In 1952,
she would star in
High Noon.

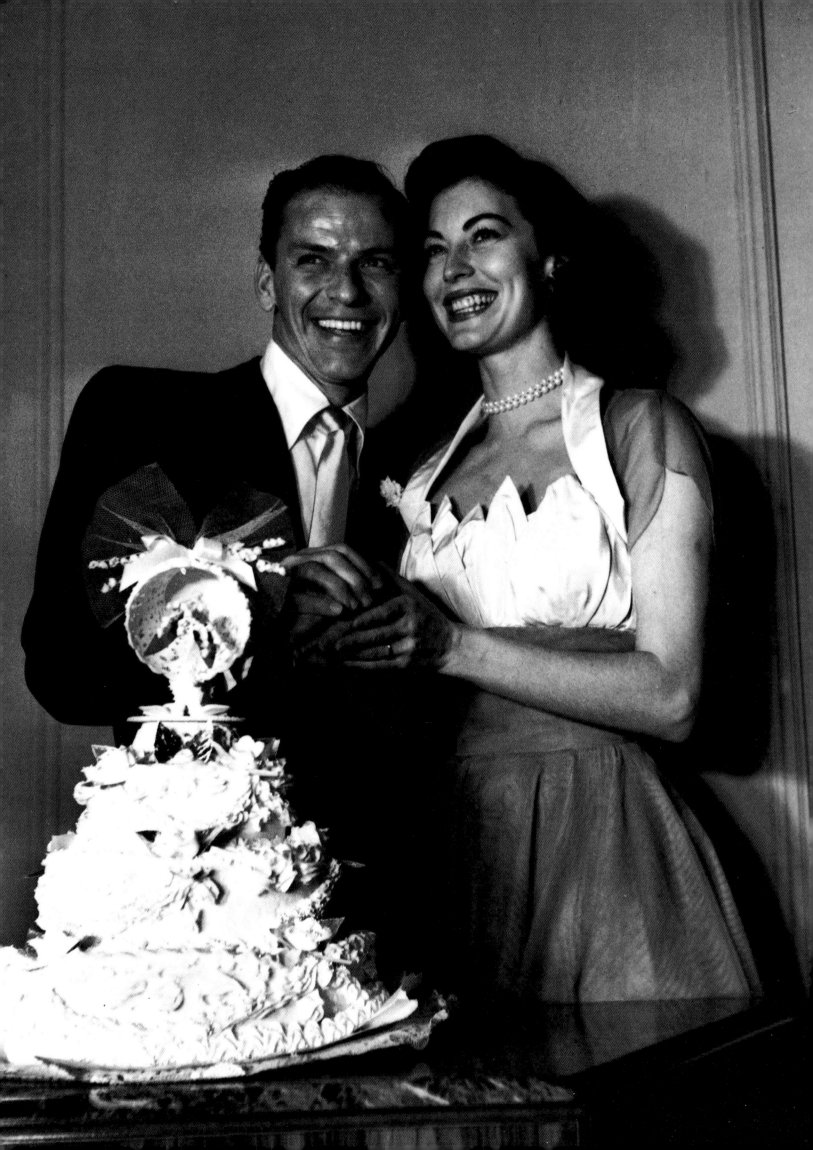

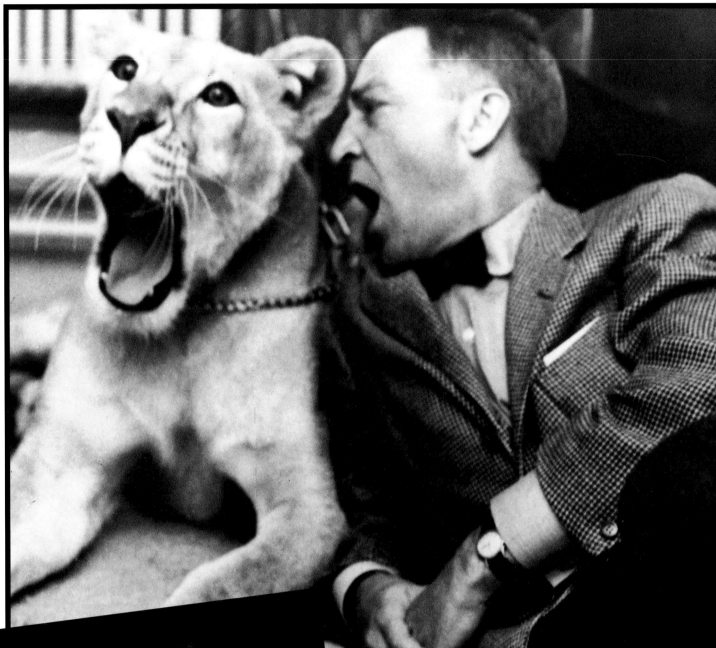

LEFT: *Perry Como and the Fontaine Sisters.* New York City, 1951. The Fontaine Sisters, a popular singing group, helped their host celebrate on *The Perry Como Show.*

ABOVE: *Garry Moore.* New York City, 1951. Television personality and game-show host Moore clowned behind the scenes with an obliging lion.

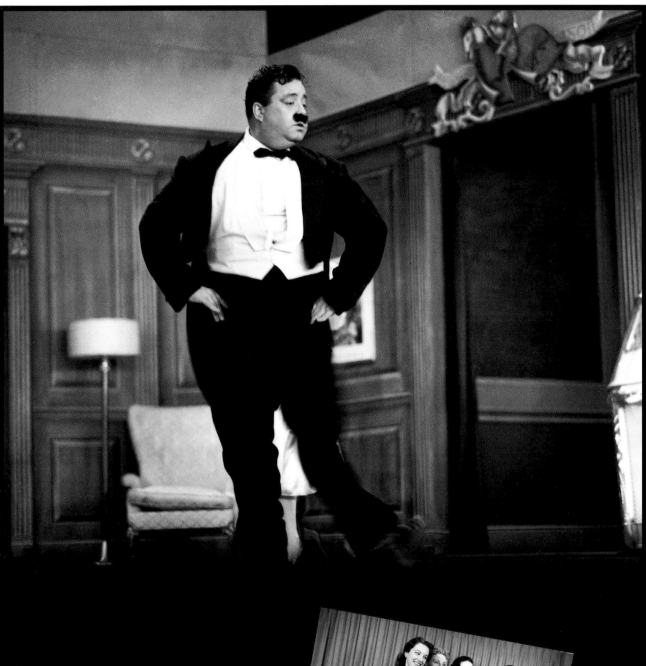

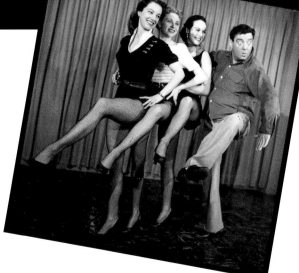

ABOVE AND RIGHT:

The Jackie Gleason Show. New York City, 1952. In the first year of his variety show, Gleason played such characters as Reginald Van Gleason III and improvised with the June Taylor Dancers.

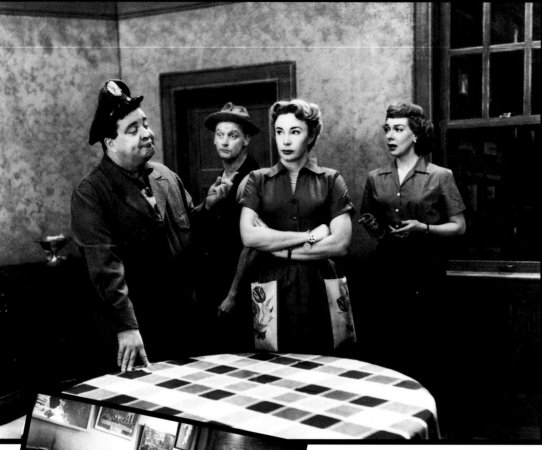

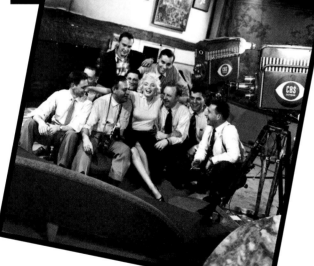

BELOW: *Arthur Godfrey*. New York City, 1955. Godfrey hosted his own television show from 1949 to 1959; his CBS radio program, never canceled, ran for twenty-seven years.

ABOVE: *Marilyn Monroe*. Connecticut, 1955. Fresh from *The Seven Year Itch*, Monroe posed with the CBS crew after an interview with Edward R. Murrow.

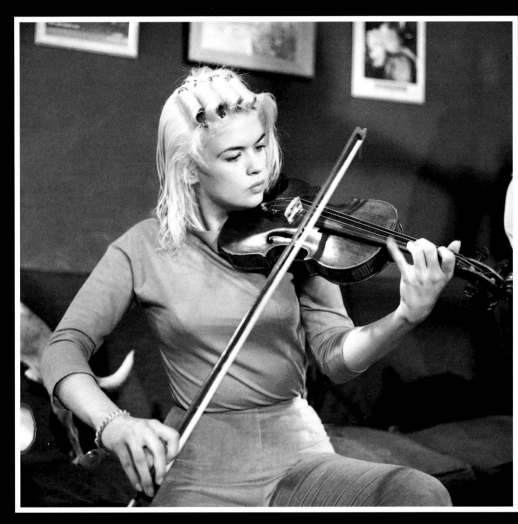

ABOVE:

Jayne Mansfield.

New York City, 1956.

Actress Mansfield,

better known for her

bosom than for her

violin playing, passed

the time behind the

scenes at CBS.

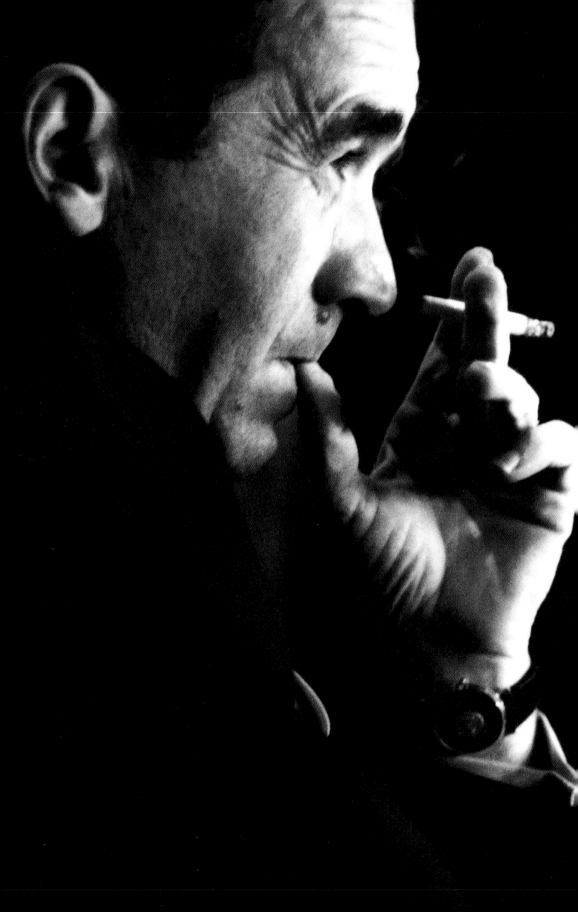

OPPOSITE: *Edward R. Murrow.* New York City, 1956. Haberman took this award-winning portrait of Murrow, one of the greatest newscasters of all time, as the newsman waited to appear on *The Ed Sullivan Show.*

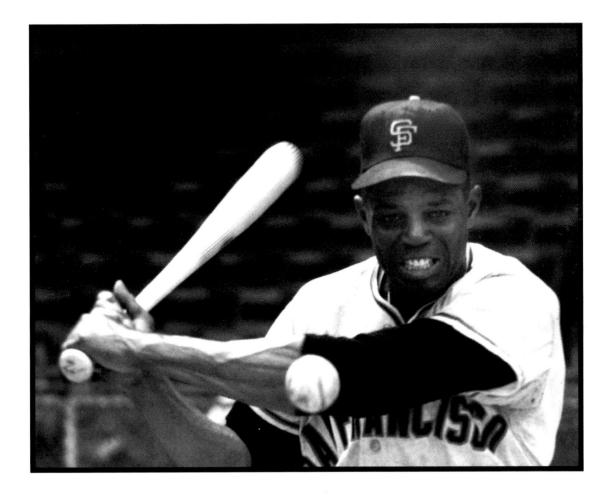

ABOVE: *Willie Mays.* Ebbets Field, Brooklyn, 1958. Only Hank Aaron and Babe Ruth hit more home runs than the "Say Hey Kid." The New York Giants had just moved to San Francisco, and Mays went with the team.

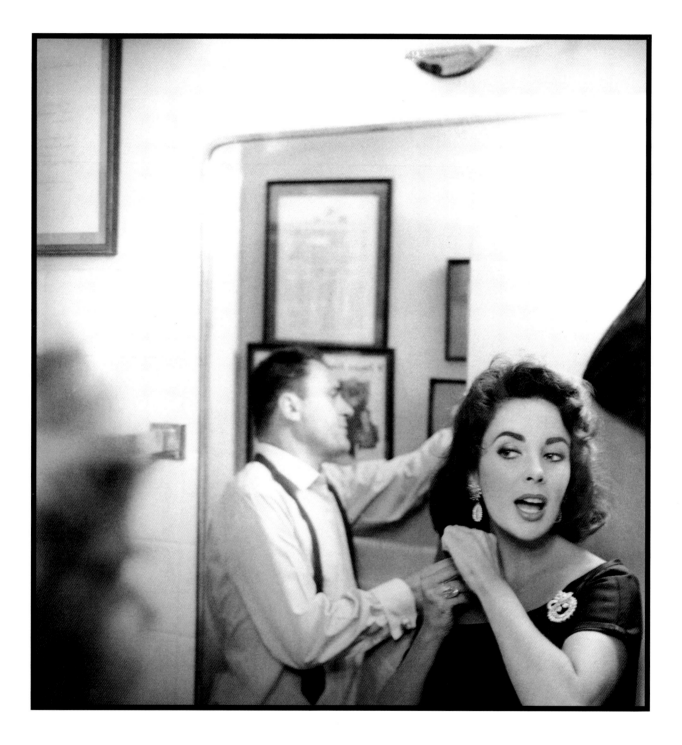

Elizabeth Taylor and Mike Todd. New York City, 1957.

Actress Taylor and producer Todd were married in 1957, but Todd died in a plane crash one year later.

Taylor had intended to fly with Todd on the plane he named *The Lucky Liz,* but she stayed home

with a cold at the last minute.

Elizabeth Taylor. **New York City, 1957.**

With her famous violet eyes, Taylor was described as the world's most beautiful woman.

One of the few to evolve from child actress to adult star, Taylor had recently given one of her

best performances in *Giant.*

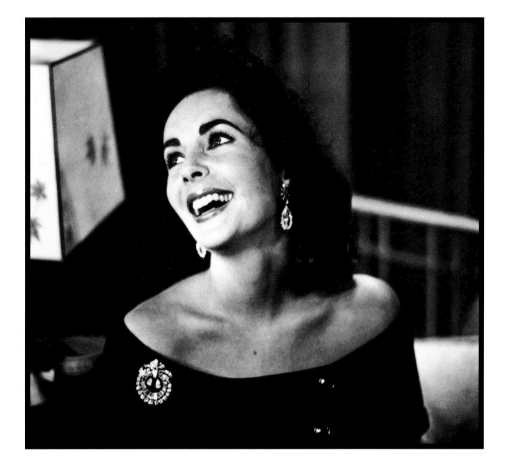

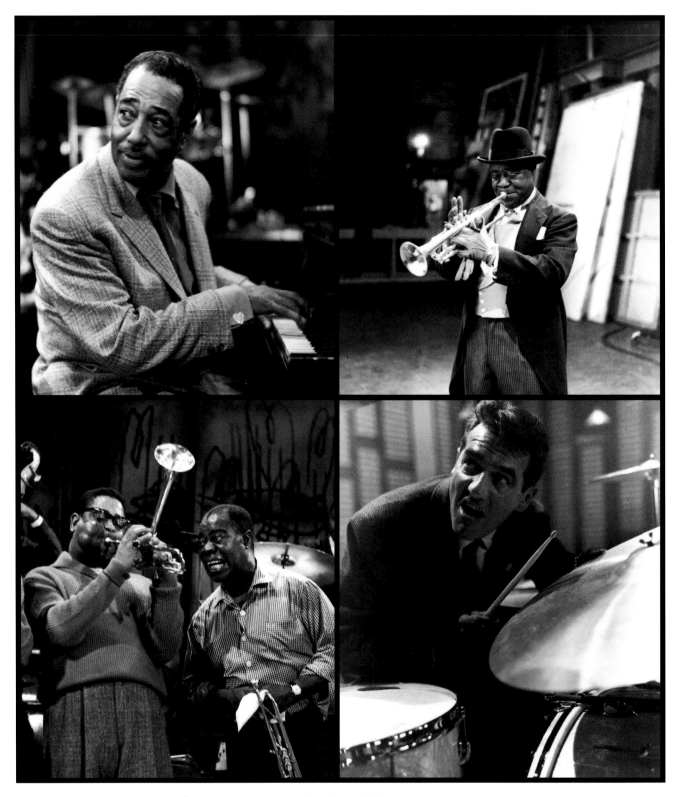

Jazz Musicians. New York City, 1958.

CBS was known for its commitment to music and featured a number of jazz musicians in its programming,

including Duke Ellington (top left), Louis "Satchmo" Armstrong (top right), Dizzie Gillespie (with Armstrong, bottom left),

and Gene Krupa (bottom right).

Leonard Bernstein. New York City, 1958. In 1957, composer and conductor Bernstein

had been named sole musical director of the New York Philharmonic, the first American to hold that position.

His *Young People's Concerts* on CBS would become the longest running

special television series for children.

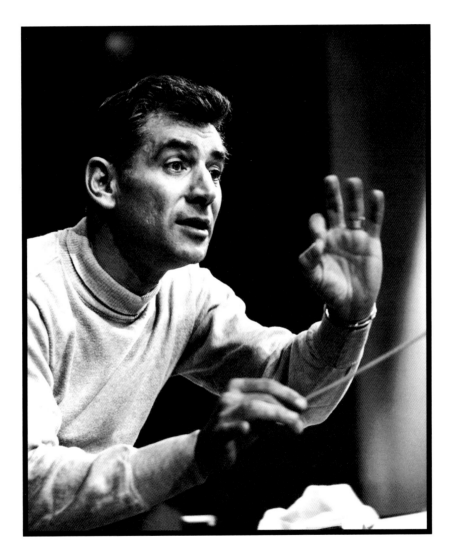

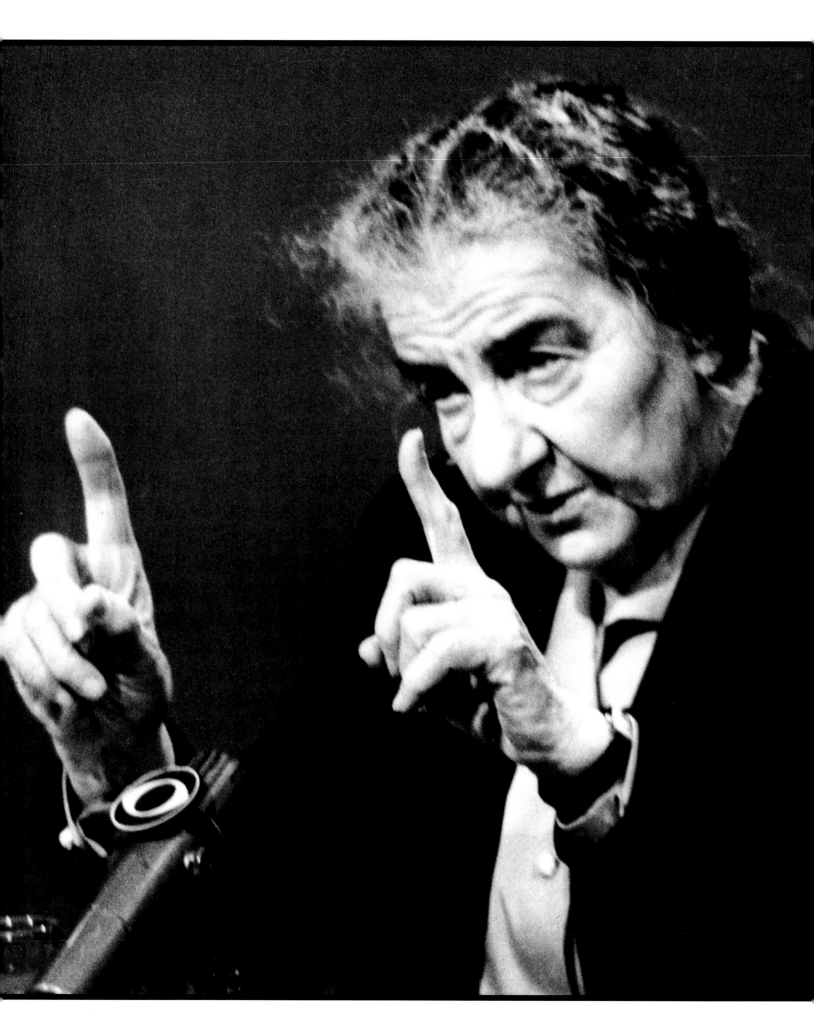

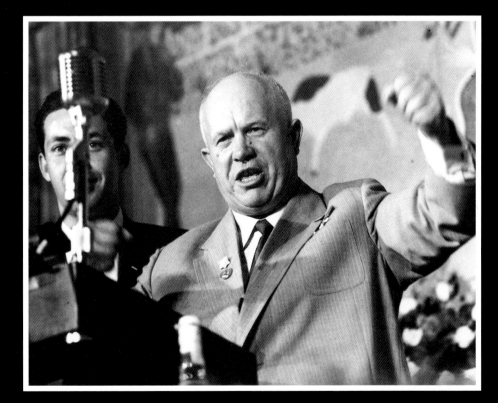

Marilyn Monroe. 1959. Following Khrushchev from New York to Hollywood,
Haberman was surprised when his traveling companion turned out to be actress Monroe.
During the flight, she dozed off and Haberman snapped this informal picture—and later joked
that he had "slept with" Marilyn Monroe.

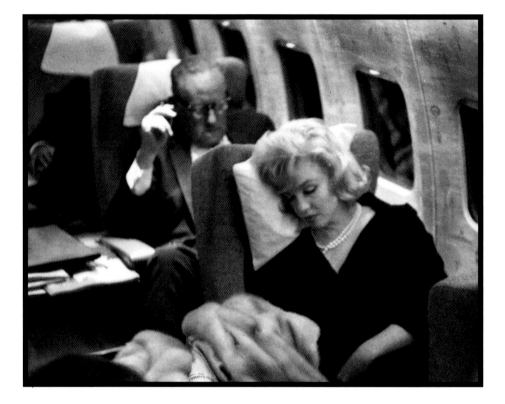

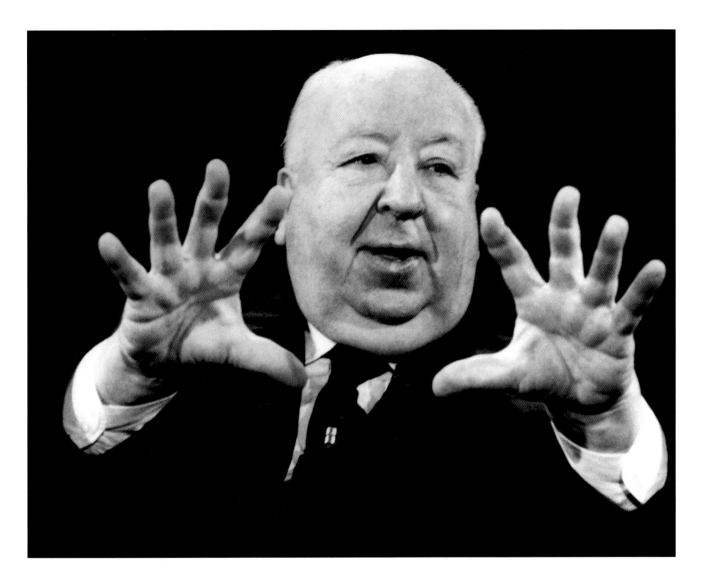

Alfred Hitchcock. New York City, 1959.

The "Master of Suspense" was at the height of his television career in 1959

with his mystery show *Alfred Hitchcock Presents* and would shortly release *Psycho* on the big screen.

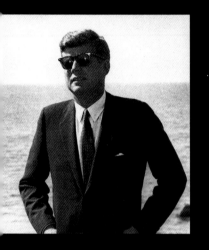

19

60s

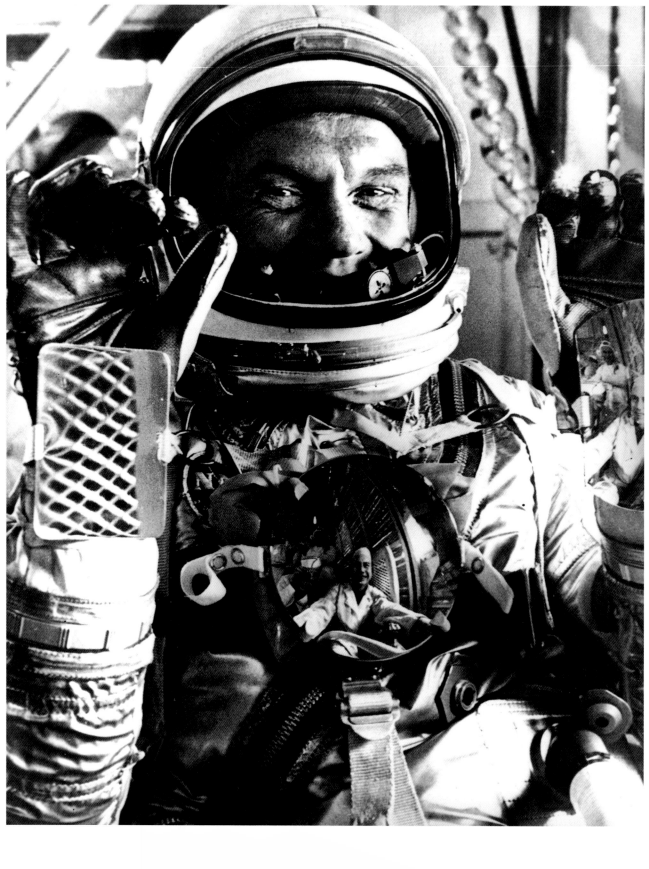

THE 1960s The Cold War was yet to reach its height as we entered the 1960s, but the decade began with promise in the form of John Fitzgerald Kennedy, the handsome war hero who would become the nation's thirty-fifth president. He set our sights on the heavens, gave us hope, and raised our expectations, both for our country and for ourselves. While he led us closer to the brink than we would ever want to be one cold October, then pulled us back from the precipice, his real army would be the Peace Corps, and he galvanized American youth into believing they could change the world.

I have a dream that one day every valley shall be exalted, every hill and mountain shall be made

Camelot ended in November 1963 with an assassin's bullet. A hard edge would color our newfound optimism. American involvement in the warring political struggles of Southeast Asia would become one of the most divisive issues in this country since our own civil war. As World War II had brought us together, Vietnam, on the heels of the Korean conflict, would tear us apart.

low, the rough places will be made plain, and the crooked places will be made straight, and the glory

In its impatience, young America still believed, and perhaps rightfully so, that it could change the world, but now those efforts would take on radical proportions. Political conventions became battlegrounds as the fight for civil rights became a militant one. Patient too long, the frustrations finally boiled over, punctuated peacefully by a massive march on Washington, and violently by cities in flames.

of the Lord shall be revealed, and all flesh shall see it together. —Martin Luther King, Jr., 1963

Our hopes would be shattered twice more with the violent losses of the Reverend Martin Luther King, Jr., and presidential hopeful Robert Kennedy. Richard Nixon would become president. But as we fought to find focus in relationships at home, we would conquer our own limits in the sky, finally reaching the moon. —Walter Cronkite

*John F. Kennedy
and Richard Nixon.*
Chicago, 1960.
Vice President
Nixon accepted
Senator Kennedy's
challenge to partici-
pate in the first
nationally televised
debate between
presidential candi-
dates; Haberman
was the only pho-
tographer allowed
on the set.

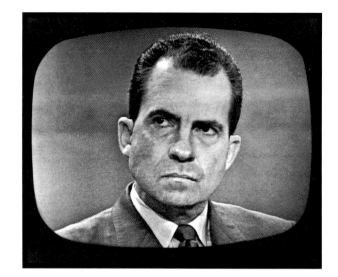

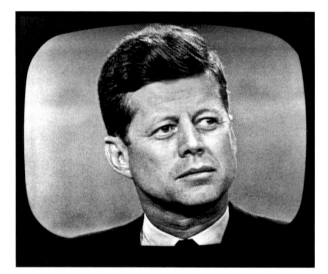

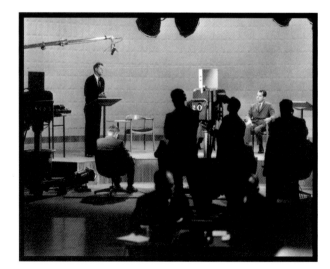

John F. Kennedy and Jacqueline Kennedy. Washington, D.C., 1961.

President Kennedy and his wife toured the capital on inauguration day. In his inaugural address,

the thirty-fifth president of the United States proclaimed,

"The torch has been passed to a new generation of Americans."

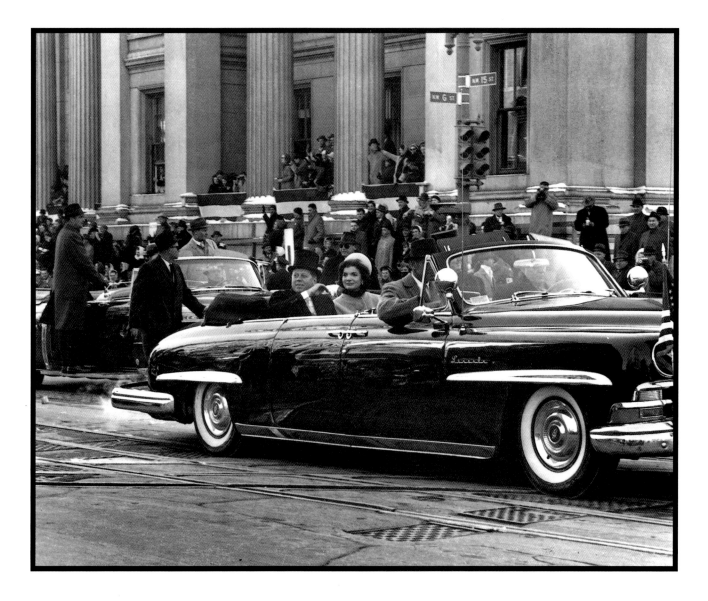

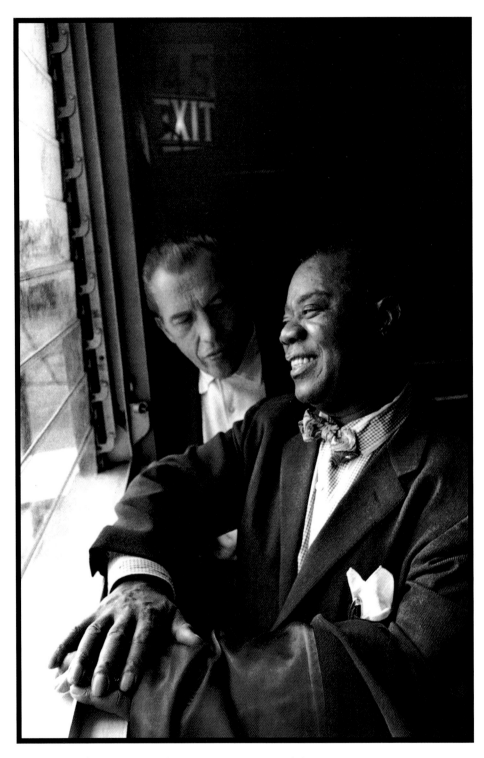

Ed Sullivan and Louis Armstrong. Cuba, 1962.

The Ed Sullivan Show traveled to the Guantánamo Bay Naval Base

to raise the troops' morale; jazz musician Armstrong was a special guest.

Covering conductor Bernstein's appearance on *The Jack Benny Show*, Haberman approached the two men and asked Bernstein to react to Benny's trademark fiddle playing—Bernstein obliged.

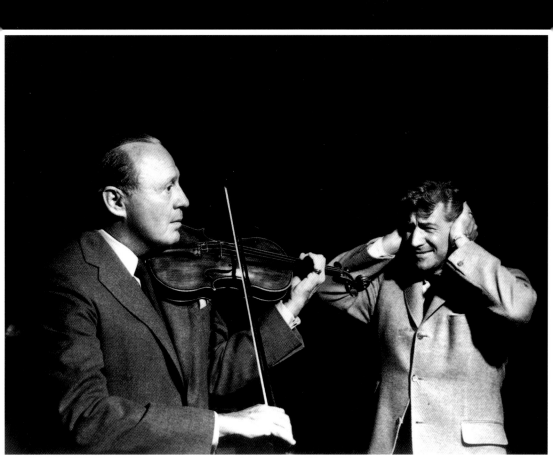

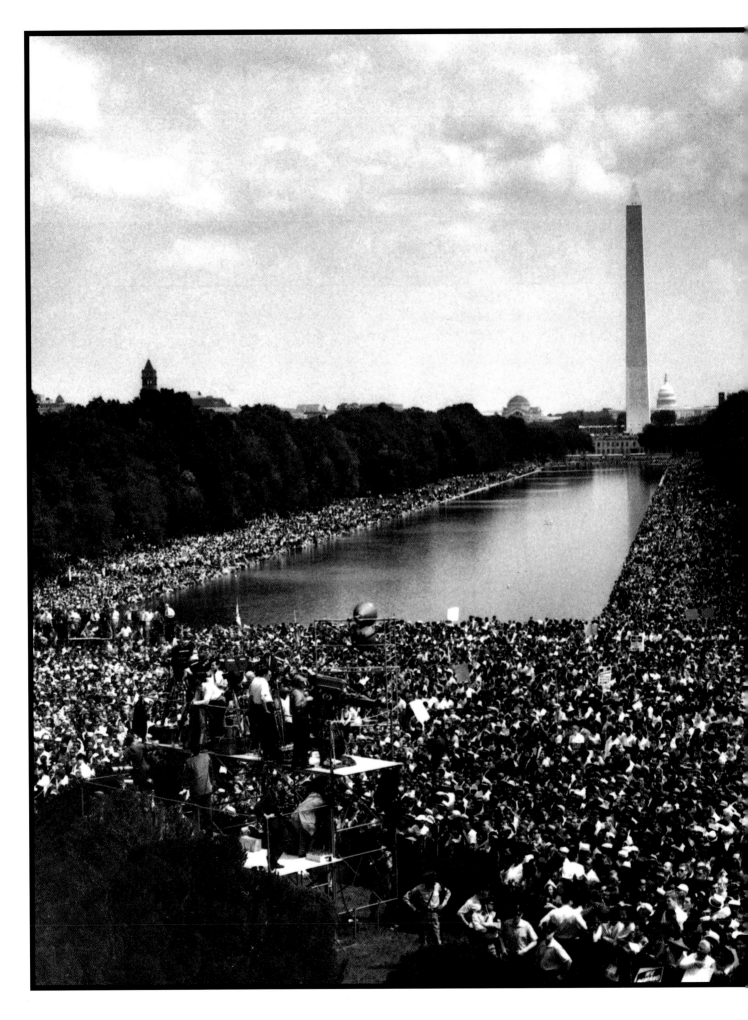

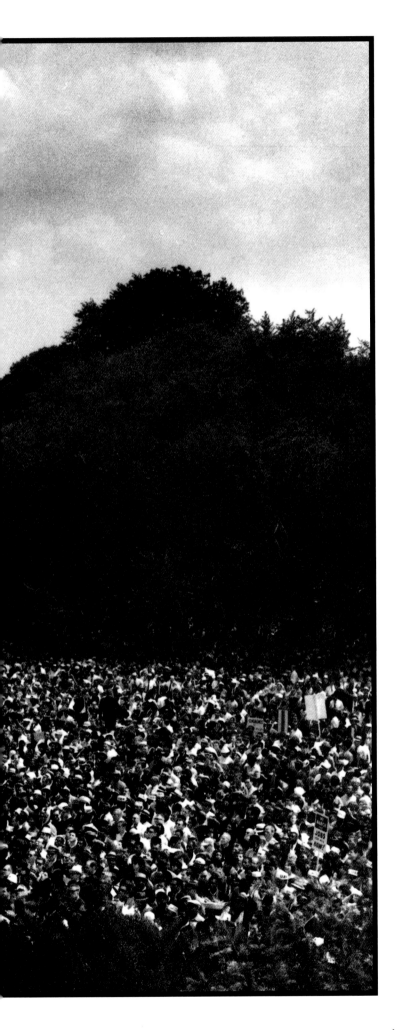

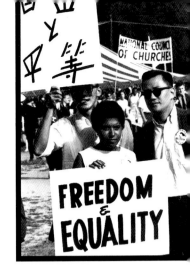

March on Washington for Jobs and Freedom. Washington, D.C., 1963. On the heels of civil rights protests and boycotts of the late 1950s and early 1960s, President Kennedy submitted a civil rights bill to Congress in June 1963. The March on Washington, the largest demonstration ever to take place in the capital, was organized by civil rights leaders to dramatize the need for such measures. More than 200,000 people took part in the August 28 event, including luminaries like contralto Marian Anderson (below).

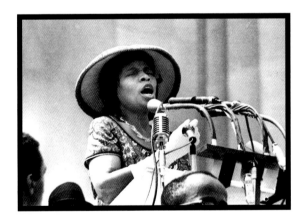

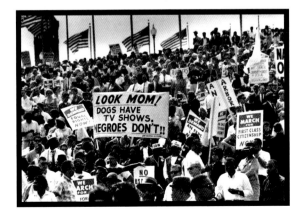

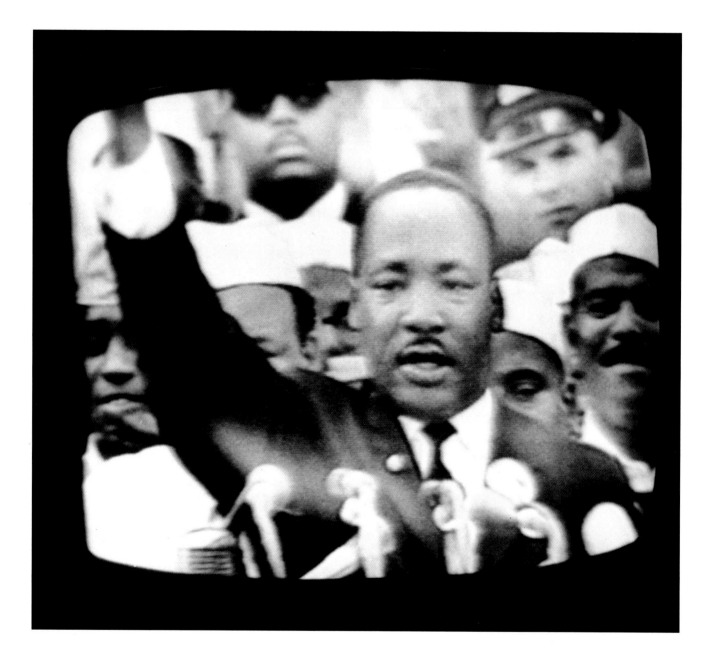

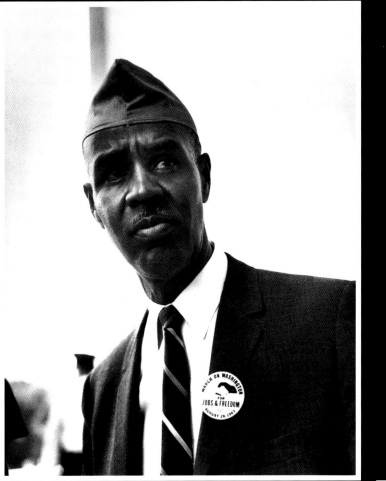

In attendance were such notables as singer and actress Lena Horne (above); Roy Wilkins, executive secretary of the NAACP (left); and entertainer Sammy Davis, Jr. (below).

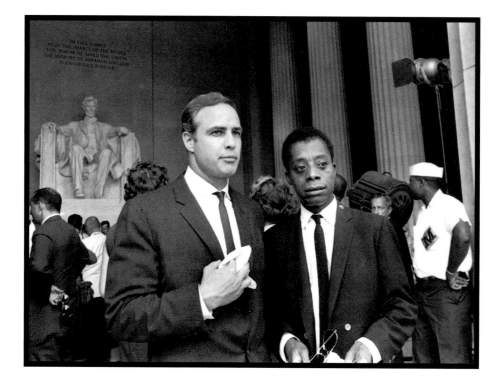

March on Washington for Jobs and Freedom. Washington, D.C., 1963.

Actor Marlon Brando and writer James Baldwin listened to speeches at the Lincoln Memorial (above),

and an array of picket signs rested at the foot of the Washington Monument (opposite).

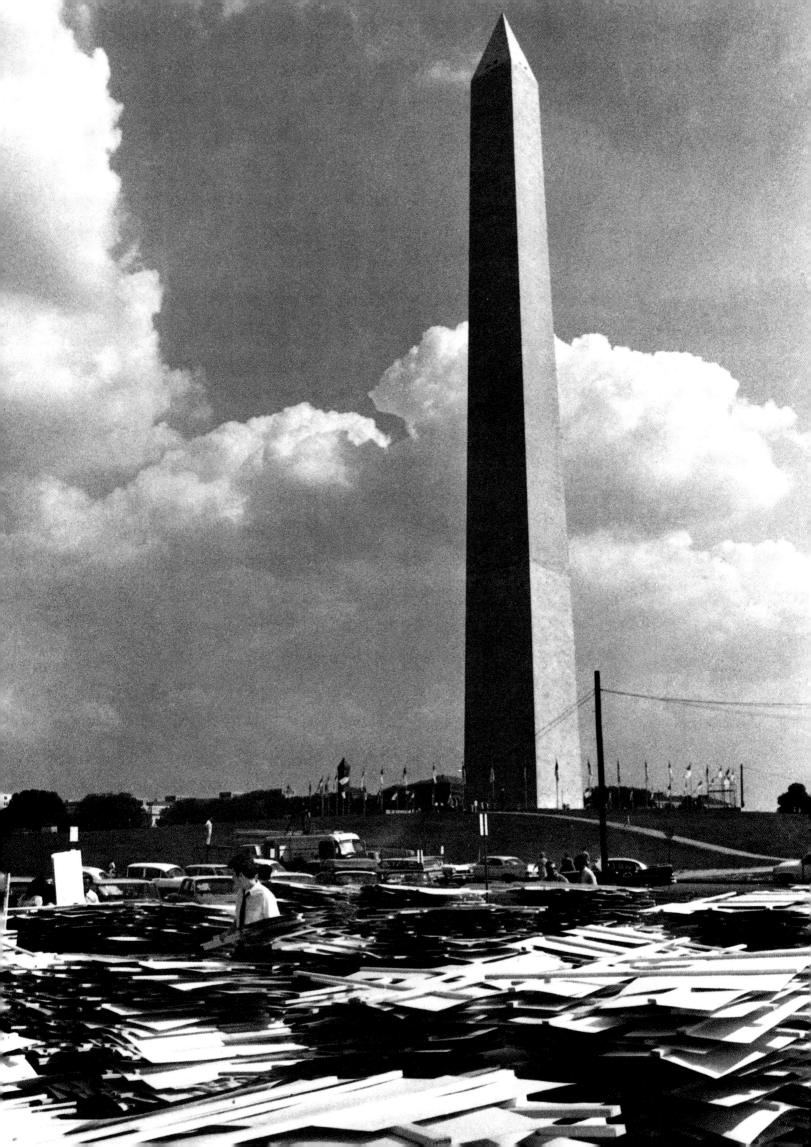

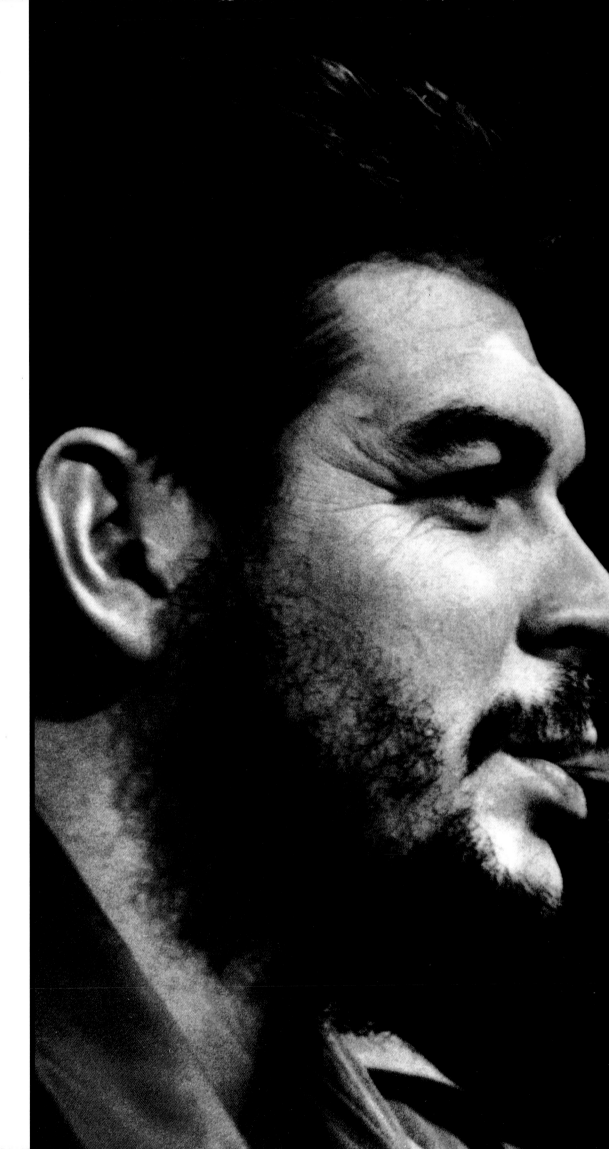

Ernesto "Che" Guevara.
New York City, 1964.
In 1956 Guevara had
joined Fidel Castro in
his campaign to over-
throw the Batista regime
in Cuba. A living legend
among revolutionaries,
Guevara served as
diplomat and adminis-
trator in the Castro gov-
ernment; in conjunction
with a visit to the United
Nations, he appeared on
Face the Nation.

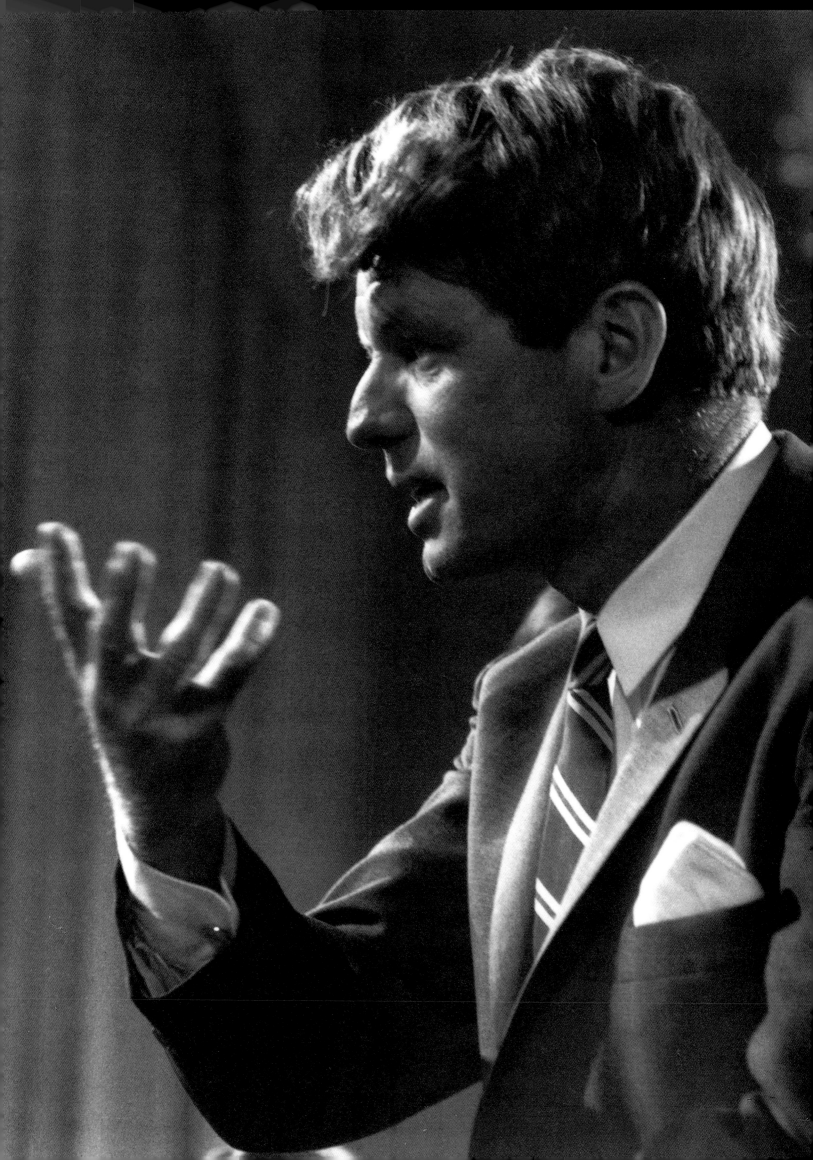

161

The Kennedy Family. Hyannis Port, Massachusetts, 1964.

Haberman photographed the Kennedy family in their Cape Cod home,

compiling the pictures into one of his special albums. Patriarch and businessman Joseph Kennedy, Sr. (below),

had been appointed to political and diplomatic offices in the 1930s and had a strong hand in his sons' political

careers. Having resigned as attorney general, Robert Kennedy (opposite) had recently won a Senate seat; while

campaigning for the Democratic presidential nomination in 1968, he would be assassinated.

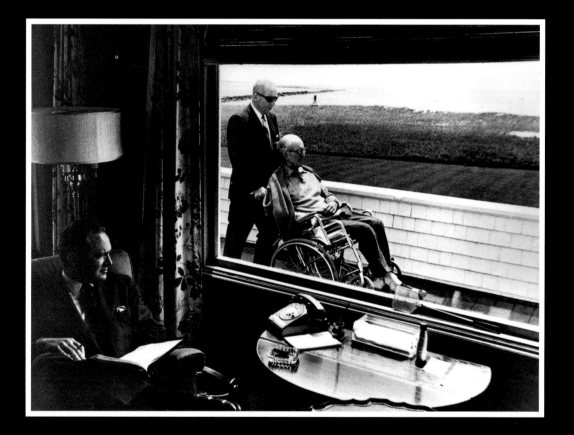

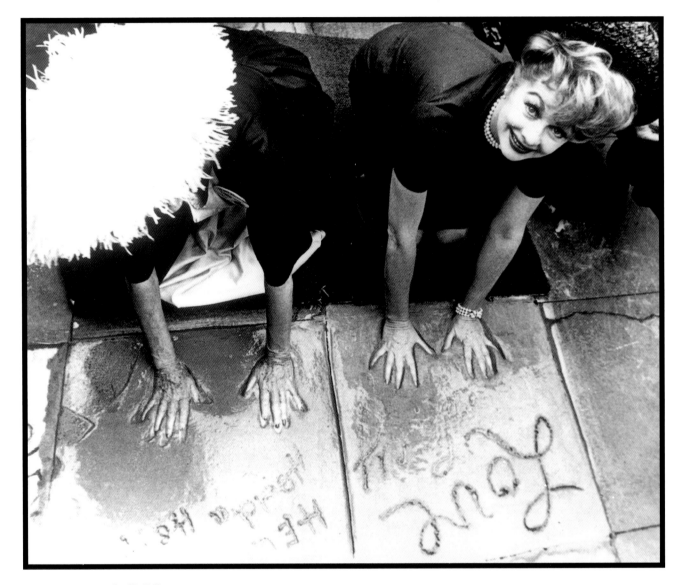

Lucille Ball.
Flushing Meadow,
Queens, 1964.
When the New
York World's Fair
held its commemo-
rative "Lucy Day,"
comedian Ball left
a lasting imprint
next to gossip
columnist and
famed hat-wearer
Hedda Hopper.

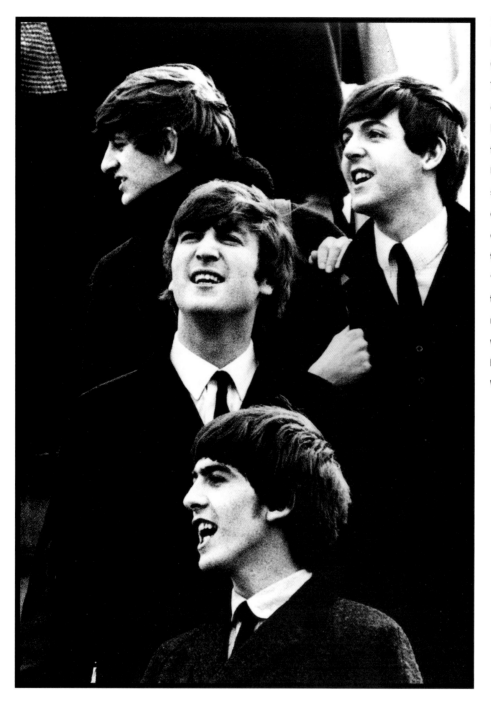

The Beatles.
Kennedy Airport,
Queens, 1964.
The Beatles
clinched the British
Invasion with their
first visit to the
United States. Upon
seeing the crowd
of screaming wel-
comers (bottom),
the Beatles asked,
"My God, who are
they?" Haberman
replied, "That's
what they want to
know about *you.*
Who *are* you?"

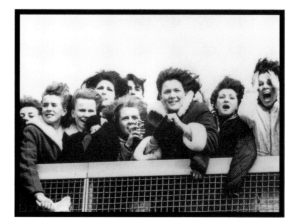

TOP AND BOTTOM:
Jackie Gleason.
1965. The "Great
One" moved his
television show,
revived in 1962,
from New York to
Florida on this
twelve-car private
train, "The Great
Gleason Express."

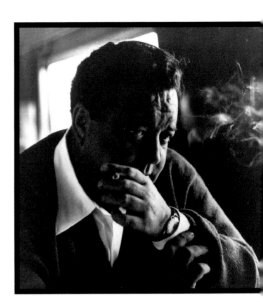

LEFT:
Barbra Streisand.
New York City, 1965.
Singer and actress
Streisand's supper
club performances,
television appear-
ances, and albums
had made her a star,
and she capped her
success in 1964 with
her Broadway perfor-
mance in *Funny Girl.*
In 1965, her CBS
special *My Name is
Barbra* won
an Emmy.

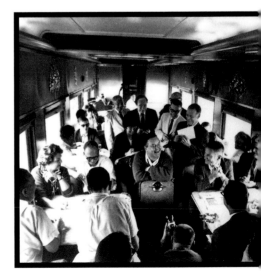

Mickey Mantle.
Fort Lauderdale,
Florida, 1965. One
of the all-time
great Yankees,
the "Commerce
Comet" took a
quiet moment dur-
ing spring training.
Mantle ended his
seventeen-year
career in 1969
with 536 home
runs.

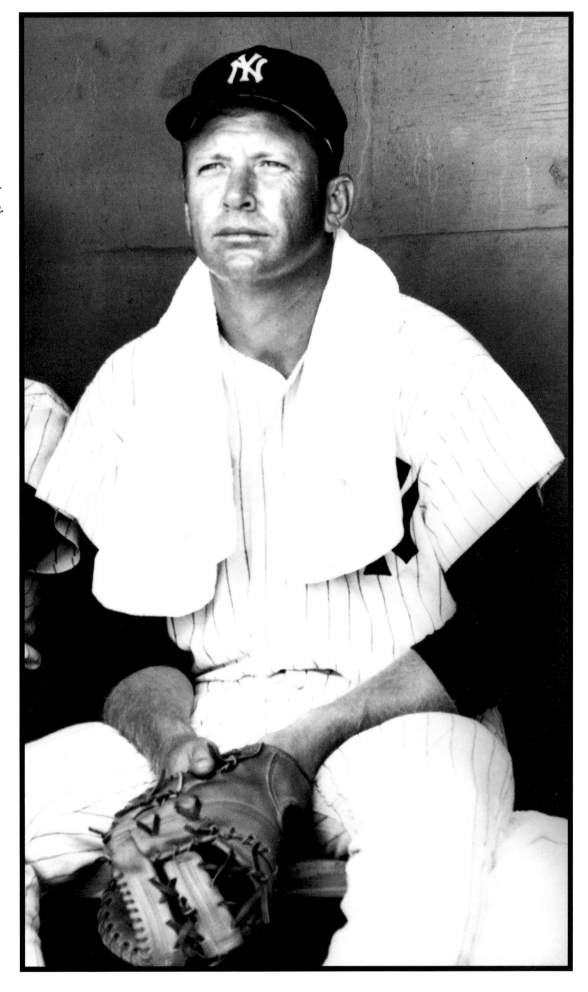

RIGHT:

Muhammad Ali. New York City, 1965. Boxing great Cassius Clay had defeated Sonny Liston for the world heavyweight title in 1964. Clay returned to the ring as Muhammad Ali in 1965 and once again triumphed over Liston, saying, "I told you I had a surprise."

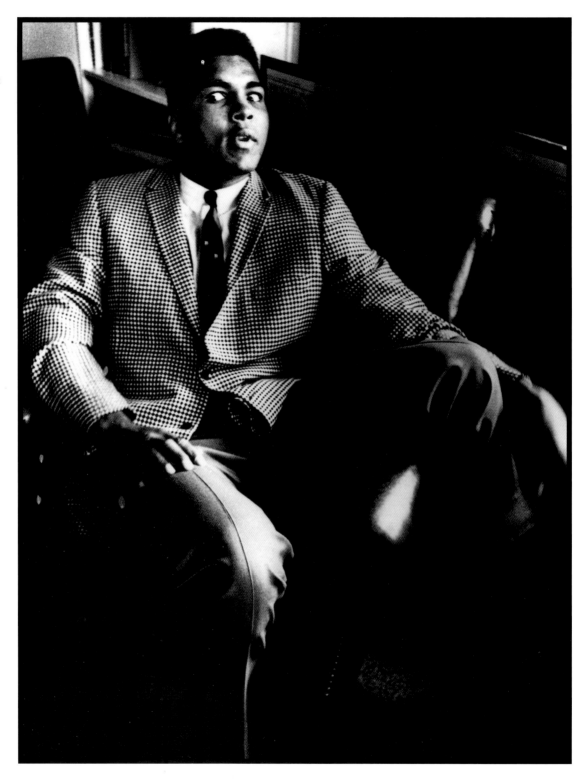

OPPOSITE: *Martin Luther King, Jr.* New York City, 1965. Recent Nobel Peace Prize–winner King had seen part of his dream realized with the Civil Rights Act of 1964. Though the King-led Alabama march from Selma to Montgomery helped win support for the Voting Rights Act of 1965, the civil rights movement would begin to splinter.

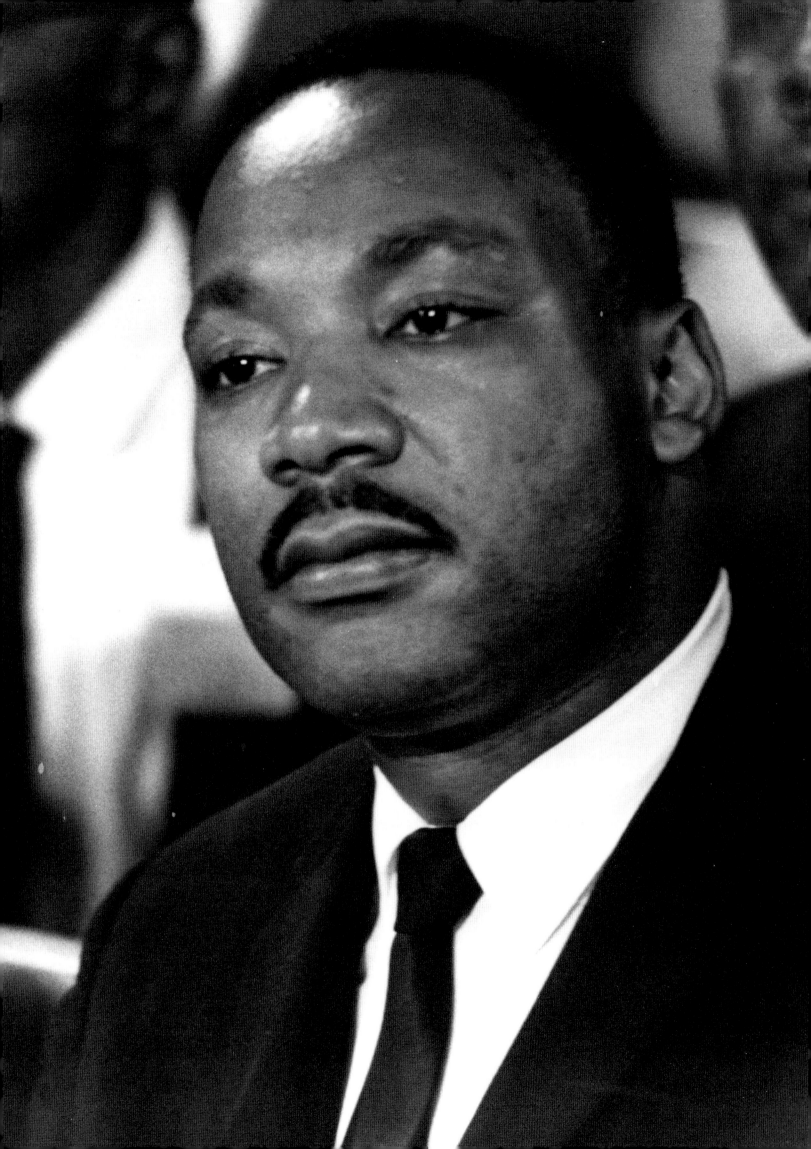

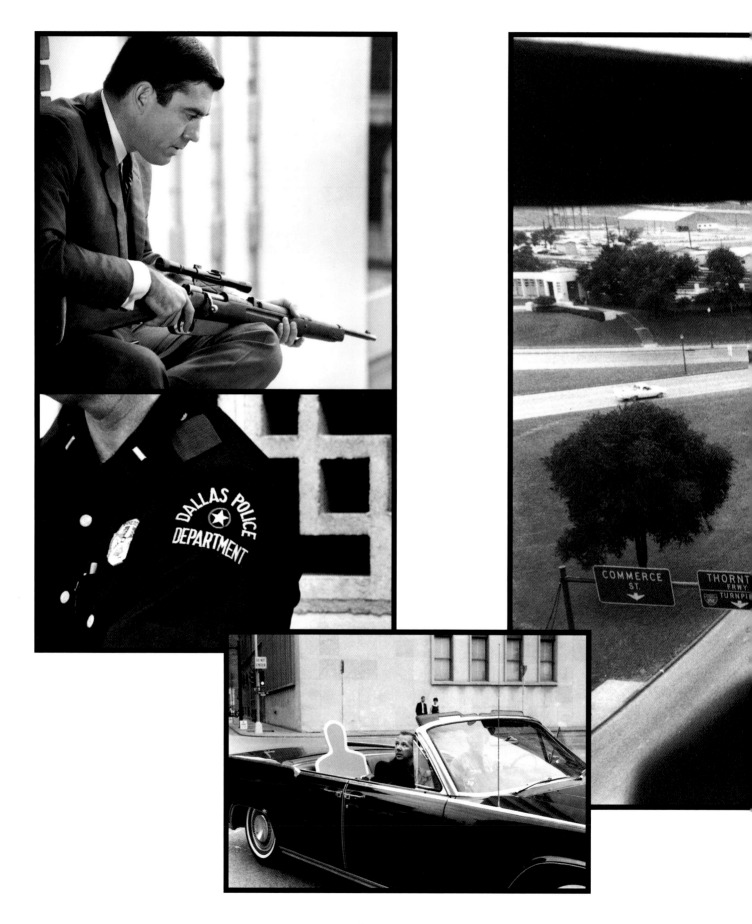

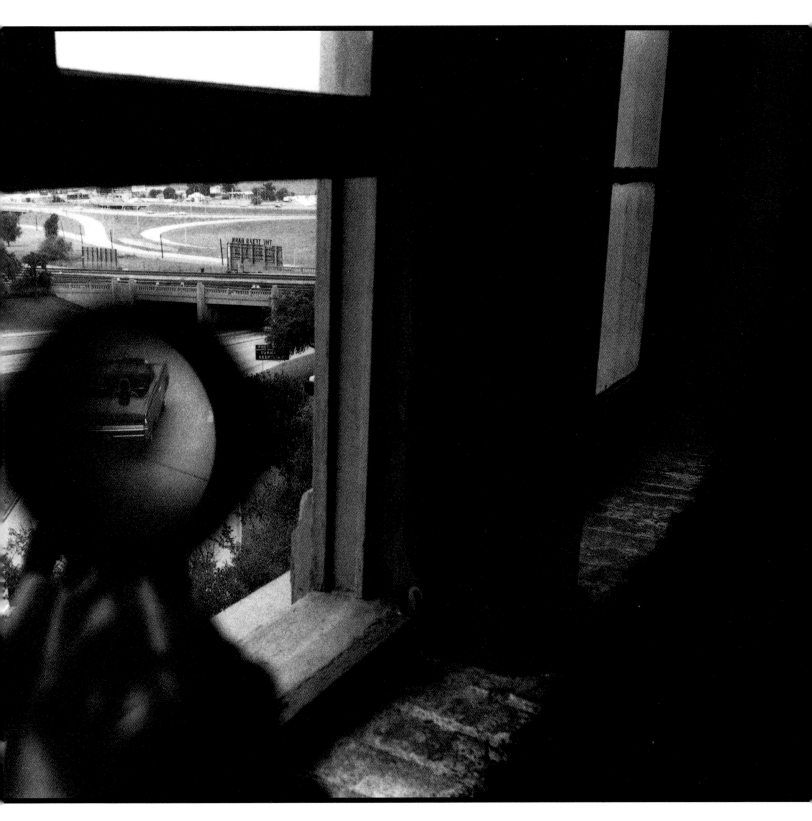

The Warren Report. Dallas, 1967. Almost four years after President Kennedy's death, CBS aired a four-part investigative series, entitled *The Warren Report*, featuring Dan Rather (opposite top) and Walter Cronkite. The special report examined the 1964 findings of the Warren Commission, in some instances using reenactments to explore such questions as whether there might have been more than one assassin.

Vietnam War Meeting. Honolulu, 1966.

Left to right: Secretary of State Dean Rusk; President Lyndon B. Johnson; General William Westmoreland; Secretary of Defense Robert McNamara; an unidentified man; Admiral Ulysses G. Sharp. President Johnson conferred with his advisors before meeting with South Vietnamese premier Nguyen Cao Ky in Honolulu. By 1966, there were over 180,000 American military personnel in Vietnam, and Johnson pledged further support.

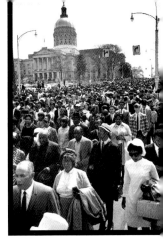

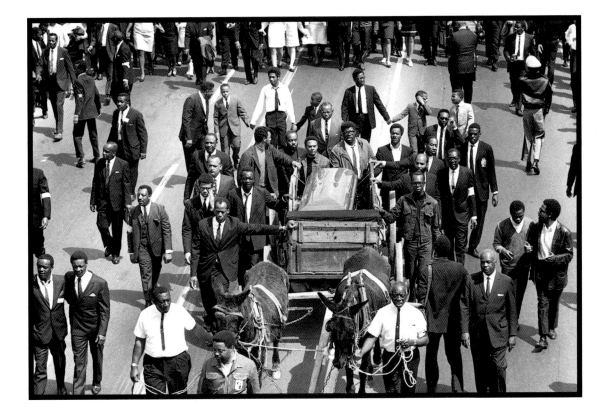

Funeral of Martin Luther King, Jr. Atlanta, 1968.

"If a man hasn't discovered something that he will die for," Reverend King said in 1963, "he isn't fit to live."

The civil rights leader's assassination on a Memphis balcony sent shock waves throughout the country.

One hundred thousand mourners streamed behind King's coffin in a memorial march.

Stop the War. Columbia University, New York City, 1968.

After student protestors barricaded themselves inside Columbia University buildings,

their forcible ejection by police officers spawned campus-wide protest, shutting down the school for

the rest of the semester. One of the major Vietnam-era university demonstrations,

the Columbia episode inspired similar activities across the country.

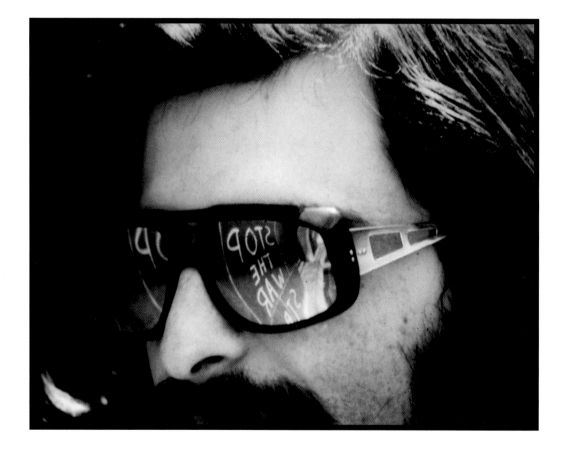

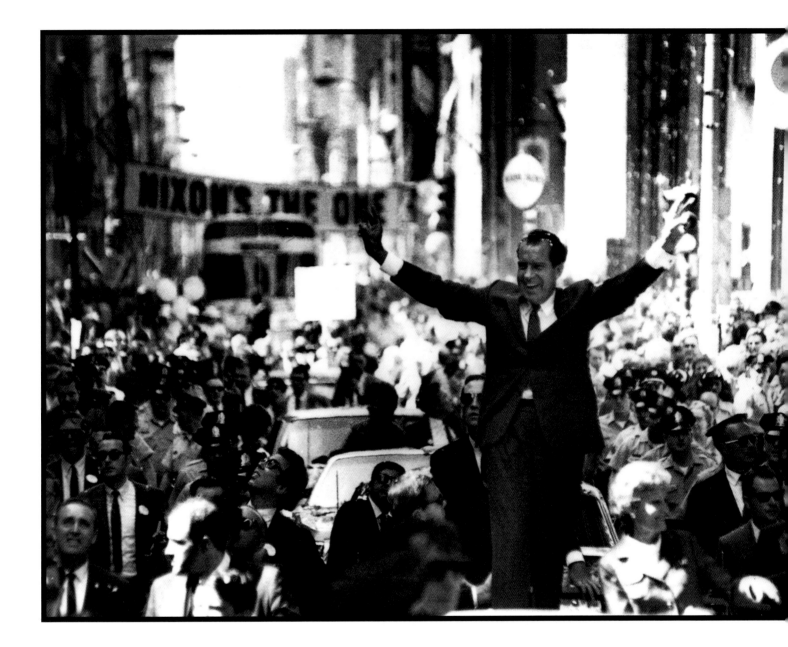

Nixon Victory Parade. Washington, D.C., 1968. Though Haberman had been a lifelong Democrat,

never particularly fond of Richard Nixon, he was asked to be the official photographer for Nixon's presidential campaign.

Nixon's victory over Democratic candidate Hubert Humphrey marked the end of Haberman's association with the president-elect;

Haberman was asked to continue with the new administration, but preferred to return to CBS.

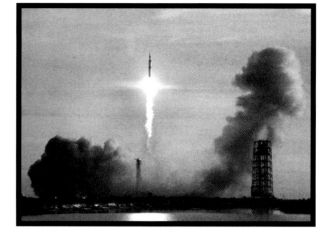

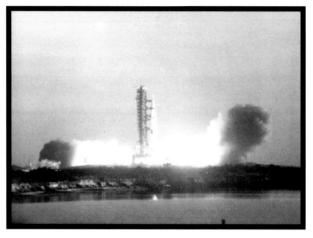

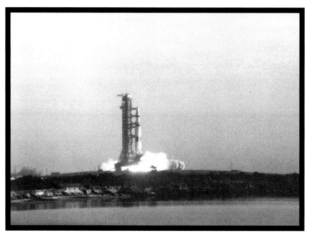

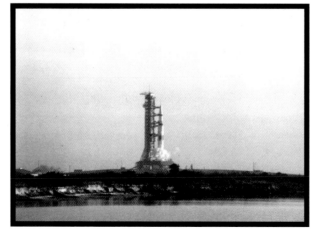

LEFT:

Apollo 8 *Launch.* **Cape Kennedy, Florida, 1968.** In 1960, NASA began Project Apollo with the goal of putting a person on the moon by 1970. *Apollo 8* launched on December 21, 1968, and reached the moon on Christmas Eve; important moments of the mission were seen via direct television transmissions all over the world. The three astronauts, William Anders, Frank Borman, and James Lovell, Jr., were the first men to leave the Earth's gravitational pull, and made a flawless splashdown after ten lunar orbits.

OPPOSITE:

Apollo 8 *Celebration.* **New York City, 1969.** The astronauts were honored in the new year with a jubilant ticker-tape parade. Six months later, Project Apollo would fulfill its mission—men would walk on the moon.

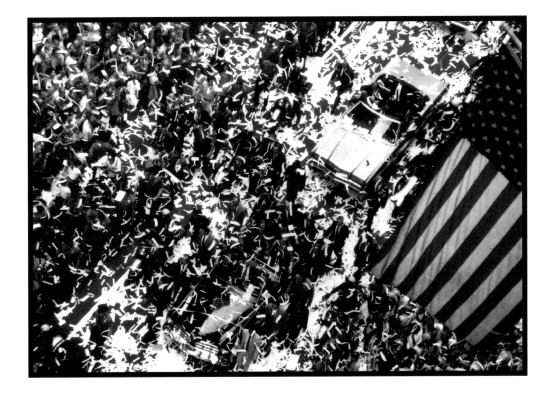

NOTES ON THE PHOTOGRAPHS Over the course of his career as a professional photographer, Irving Haberman made well over fifty thousand negatives in various formats. During his early years, he worked with the 35-mm Leica and the larger format Speed Graphic cameras. In the early 1950s he began to incorporate the Rolleiflex (2 $\frac{1}{4}$ × 2 $\frac{1}{4}$") camera and shortly thereafter discontinued the use of the Speed Graphic. The majority of the photographs that appear in this book were made from original negatives; only a few, due to loss or damage, were reproduced from second-generation negatives. As was conventional at the time, Haberman often identified his negatives with corner labels. Though most labels fall beyond cropping lines, in some instances the pictures' content requires that the labels show. Every attempt has been made to date and locate the photographs as accurately as possible; due to the nature of archival material, however, and the irretrievability of certain records, some dates and locations are approximate.